LEM

© 2012 Contrasto srl
via degli Scialoja, 3
00196 Roma
www.contrastobooks.com

For the photographs and texts
© Laura Leonelli

Translation
Huw Evans

Layout
Daniele Papalini

Production and quality control
Barbara Barattolo

ISBN: 978-88-6965-408-4

LEM

Initiation of a Little Buddha

Laura Leonelli

contrasto

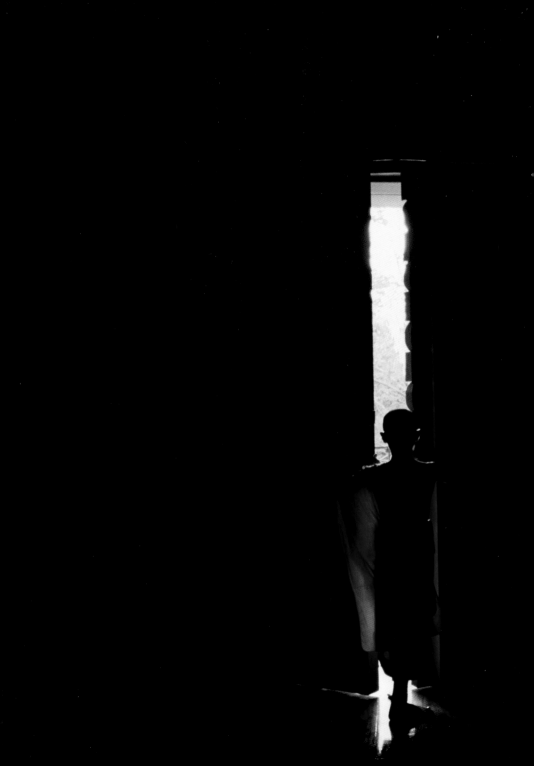

To my daughter

Index

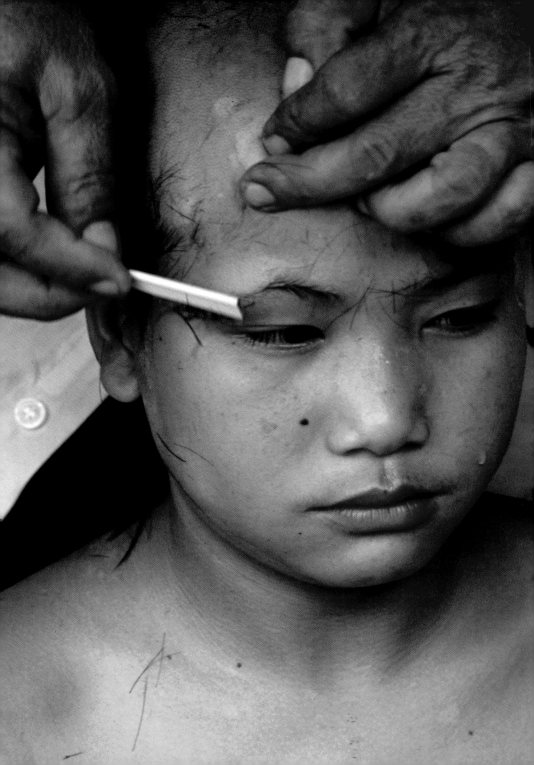

Introduction

I knew I would go back. Journeys that leave a mark on your life always start with a promise of return. Perhaps on a morning in July, when the torrential rain turns into vapour, the vapour condenses into dew that slides along the ribs of a leaf, and when a drop of that water falls onto your hand, you raise it your lips, taste it and find it has the flavour of another world. One July morning, walking down the paths that link the temples of Luang Prabang, I felt that my departure would be followed within a few weeks by a journey back again. And on the plane, flying over the golden roofs of the monasteries, the trees, the mountains, the river, and in the river an island in the shape of an eye with a pupil made of wild plants, I tried to find the reason for that desire. It wasn't a conversion. I'm not a Buddhist. Nor was it an escape. I lead a peaceful life. Neither was it a yearning for the ancient past, for its imaginary purity, for its slow rhythms to which we happily entrust the lives of others, while unable to renounce the comforts of our own time: I'm not so selfish.

Rather what convinced me I needed to return was the discovery of a point, of one of the planet's rare epicentres of feeling that are capable of condensing your own story and that of all the others, the past and the present, taking you beyond the events of daily life and touching other, more mysterious, primordial dimensions. A place, Luang Prabang, included on the list of UNESCO World Heritage Sites, where it is possible to listen to what is going on outside and inside yourself. A place on the edge, like the desert and snow-clad peaks, to be observed on tiptoe, knowing that the distance you have been granted is a precious, delicate gift. It is the signing of a pact.

I went back in October, then again in the spring, and a few days before the New Year, which is celebrated in mid-April, an important encounter took place. The nephew of my guide was about to go into a monastery. Lem, a twelve-year-old boy and the son of farmers, was to spend his adolescence at Wat Xieng Thong. Six years wrapped in the robe

and in monastic discipline in order to get a free education and construct a better future. Six years. An eternity in the heart of any child. A gesture of compassion on the part of any god who wishes to offer his children the most precious thing of all: knowledge.

At Luang Prabang, in the flower-filled shade of some forty monasteries, live around one thousand two hundred monks, and the majority of them are novices. Like Lem, at the end of their studies they will be free to go home, or they can choose to stay on and walk the path of faith. For every adolescent and adult man, from youth to maturity, the doors of the temple will always remain open, symbol of a profound tie that binds laity and religious and infuses society with the values of Buddhism: "Strong religion, strong country", I was told with pride by a young man who had spent many years at Wat Sene and later found an important job at a hotel.

Every day at dawn the city and the disciples of the Buddha meet for the *tak bat*, the begging of alms. In silence the monks parade along the main street and collect offerings from the hands of the faithful. In exchange for food the monks offer the food of the soul, prayers for the living and the dead. In exchange for their education the novices offer their jumping and skipping, their laughter, those high spirits of the shoot in the paddy-field that the Enlightened One has asked them to dowse.

Lem's entry into the monastery was fixed for the beginning of April. I went to his mountain village, met his family, slept in his house and from a distance, as a woman and foreigner, followed the ceremony of his induction. But above all I observed his mother, Peng, and saw myself in her eyes, trying to imagine her generous pain, almost as if she were being asked to give birth to her son all over again, entrusting him to a world so far away from her.

The following day I accompanied the little novice to Luang Prabang and on the journey I heard the voices of hearth and home, those female voices, of his mother and grandmother who had nourished him with endless stories, whispering in his ear not to be too sad: they were close to him, and would not abandon him. And the voices of his father, of his schoolteacher, of the Venerable monk who had looked after him on his first night in the monastery, had also stayed inside Lem. But they had

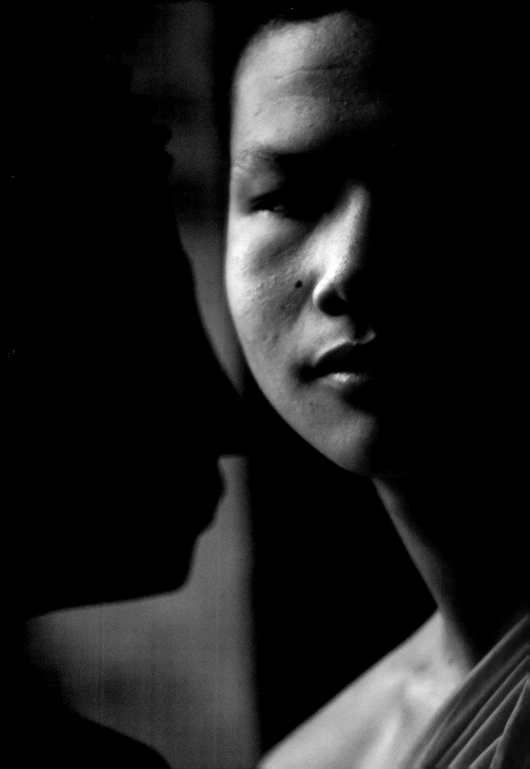

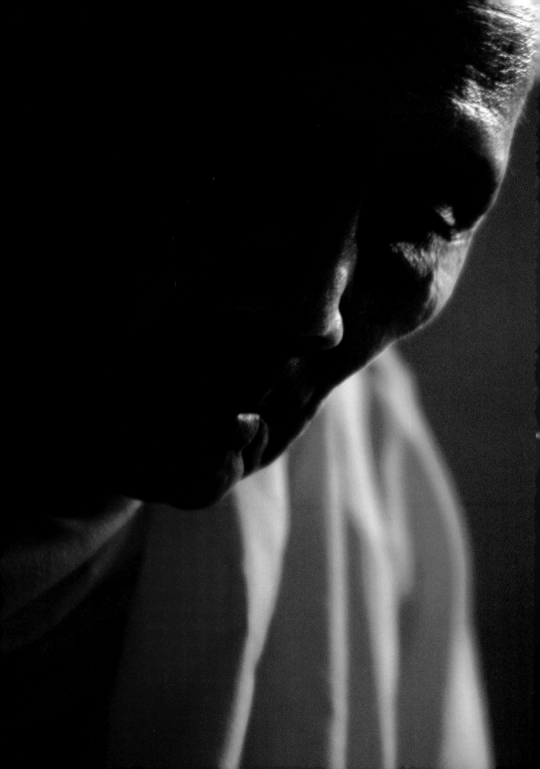

another sound. They were laws. The women's, though, were dreams. And yet despite the difference, these voices of authority and love spoke to one another, mixing up stories of saints and magical animals, good spirits and demons of the night, heroes of the faith and of human effort.

For centuries Animism and Buddhism have coexisted happily in Laos and under the serene gaze of the Buddha fly swarms of heavenly and wicked spirits, each of them worthy of a prayer and a legend. To this ancient equilibrium, protected by the mountains and by political isolation, other voices have been added in recent years, those of the West and the more combative East. Loud, seductive voices that have brought affluence, but that threaten to sweep away the beauty of this place, right down to its foundations. Defending yourself is a duty. "Buddhism will not be vanquished by the new models, but will go along with change without changing the core of its message", I was told by Satu Sai, one of the most enlightened and uncompromising monks of Luang Prabang.

On his arrival in the city Lem discovered a vital and confusing world. One image after another, the monastery, the cell, the pictures hanging on the walls of the cells, the prayers, the language of the prayers, Pali, and then the streets, the shops, the foreigners, more languages, that English to be studied even at night, and then another music, a different self-assurance, other riches. And in the evening, driving out every thought, simplifying every desire, there was hunger, for Theravada Buddhism, the "Teaching of the Elders" adopted in Laos, the school most faithful to the message of the Enlightened One, permits just two meals a day.

For three years I followed Lem and the monastic community of Luang Prabang, in every season, at every festival, catching the moments of growth and those of emptiness. Together with Lem I saw the first light of day when fire illuminates the dark, and in the evening I listened to the sounds of the forest while watching a young monk in meditation. And following the rhythm of nature, in the breath of the dawn that awakens bodies and in the darkness that relaxes them, I imagined Lem's first seven days exploring his new home and his new family.

Day after day I saw him take his first steps, curious and frightened, close to his companions and all alone, caught within the horizons of a child who loved cartoon films and would like to have had a computer, and in contact with the ultimate destiny of life, in the ashes of a funeral and beyond, among the lines on the face of an old man who had chosen the monastery to bring his journey to an end.

At the end of this very long week, which harked back to the myths of the origin of the earth and looked forward into the future of a novice, came New Year's Day and the rain. One year has ended, another is about to begin. Lem has taken part in the procession and has paraded along with the symbol of the city, the Buddha Phra Bang. Following the Master the little monk has entered the immense and turbulent river of consciousness. No one can tell how many times Lem will be willing to plunge into this current again, to make this often painful crossing, and what he will feel when he reaches the other bank. Everything is still uncertain, but it is this uncertainty, as green as a bud in the forest, that makes Lem such a marvellously receptive being.

Sire, that this sorrow may perish away,
and that no further sorrow may arise.
This I am seeking to attain.
(Milindapañha, 2)

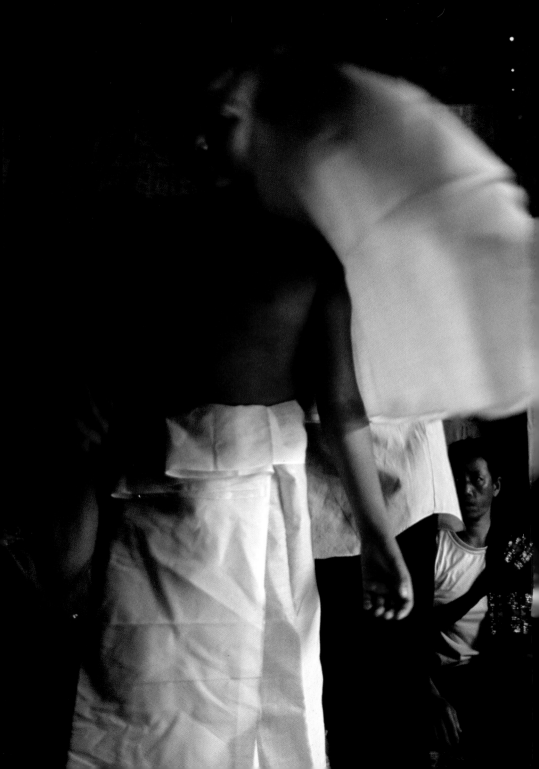

Birth

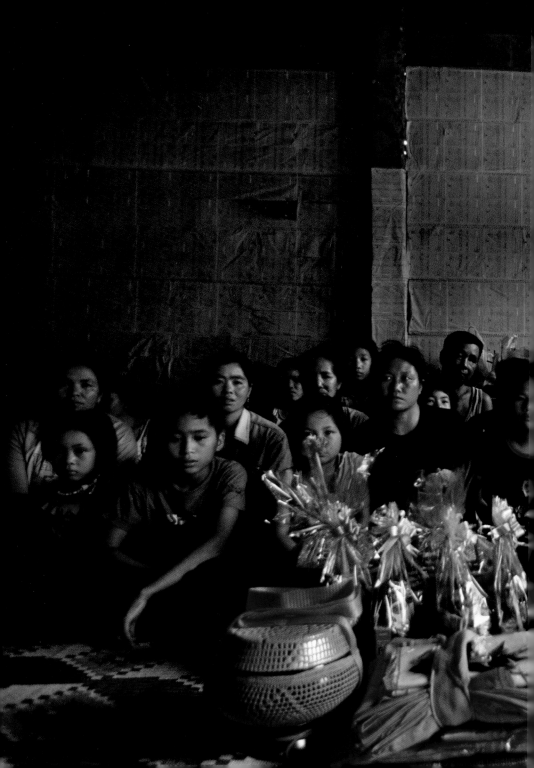

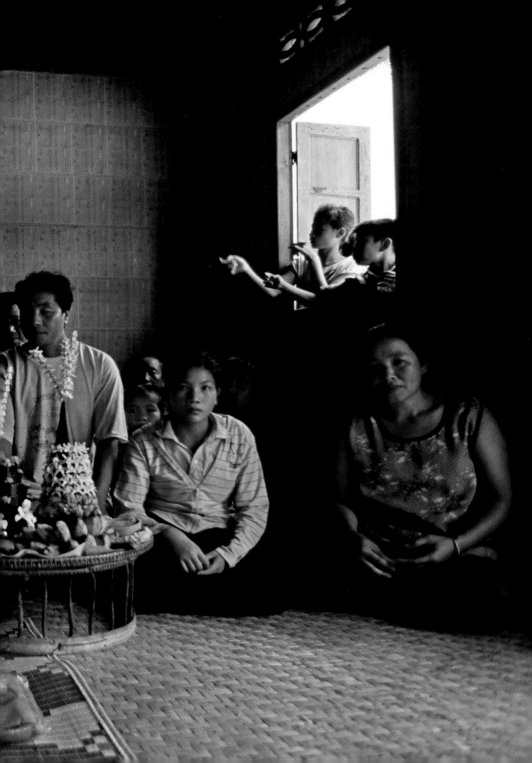

p. 18:
A moment in the ceremony of Lem
taking the habit.

Previous double page:
Another world.
The Banphasa, the ceremony mark-
ing the entry of a novice into the
monastery, is celebrated in a house
at Nam Nga. Everything is ready,
the offerings, the monk's kit. Lem,
twelve years old, will soon leave his
family. His parents and friends gather
around him for the last time.

The clouds have arrived. For days the lowering sky above the horizon of Nam Nga has been white. Everything is waiting for the rain: the plants, the animals, the people. In a week it will be New Year's Day, which falls in mid-April, and at last that mourning sky, of a colour that negates the lushness of nature and symbolizes the end of life in this part of the world, will yield to the prayers of the faithful and bathe every living creature with its drops. Even the river, which gives its name to the village and to its small monastery, knows that before long its banks of sand and grass will be under water again. And the water will be mixed with the dust of the only road that leads to the village, running along the mountainside between burnt forests and their still warm ashes. These are days of rest in Laos. The dawn has just begun to clear away the dark. The frogs and birds are waking up, and with them the women. Peng is in the kitchen getting breakfast ready. She has lit the fire and a knife is lying on top of the vegetables. The same old gestures, but today is different. They are gestures to be remembered. Today her son Lem is entering a monastery.

Lem is twelve years old and will spend the next six years in a temple in Luang Prabang, three hour's drive from his village. Lem has never seen this city, nor has he ever seen the first rays of dawn glinting on the golden peak of Mount Phu Si, nor has he ever heard the noise of the Mekong and its current, where boats leave long wakes as they come into land. His father Lan, who's a farmer, has been talking to him about the life that awaits him. Together, father and son, they've gone hunting, they've put out fish traps and they've planted teak saplings, but will have to wait another twenty years before felling them and planting them again. Lan does not want his son to be a farmer; he would rather not have been one himself. In this landlocked country with no escape routes, covered with forests and mountains, there is no other choice for the children of poor people. The colleges are far away and it costs too much to move to the city. Rent, clothes, food are all too expensive. The monasteries on the other hand open their doors free of charge and offer, along with Buddhism, its sacred tongue Pali and its law, the Dhamma, the subjects of a

Sacrifice. Under the eyes of his father and the rest of the family, Lem begins his metamorphosis. First step, the shaving of his head and eyebrows. The job is done, amidst drops of water and tears, by the Achan, the master of ceremonies.

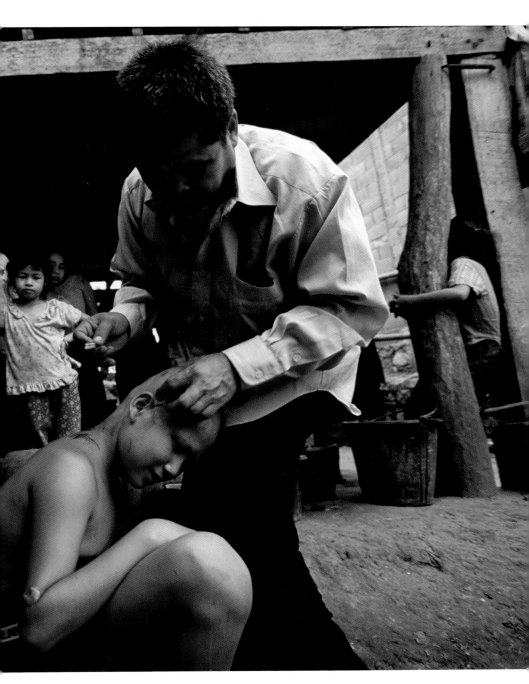

normal course of studies. But as in every pact between humans and the
gods, and in every passage to a new, more adult, more conscious age, the
person who enters the sacred circle of the monastic order, the Sangha,
will have to offer something precious and irreplaceable in exchange.
Lem will offer his adolescence. And with it his childish games and play,
and that caress his mother gives him every evening before he falls asleep
under the still cold blankets, wishing him *norn yim*, "sleep with a smile."

In a few hours Peng will no longer be able to touch her son. She who in
giving birth to him had made herself mother nature, cloud heavy with
rain and rice bed, will have to stand aside and like every woman, ances-
tral force at the origin of life, give way to another vision of the world,
one that is more male than female. While Lem still wears the white
tunic, the first skin of a creature undergoing metamorphosis, Peng will
be there next to him, standing. Then her son will become a little Bud-
dha, wrapped in the orange mantle, and she will go down on her knees
to him.
But there is still a bit of time before they separate, one last breakfast to-
gether: a cup of rice in chilli sauce, vegetable soup, crackers made from
river algae. Lem is very fond of them. And the relatives, neighbours and
friends who are coming to the farewell party must be greeted and given
a meal. The room, which opens onto the entrance, is still empty. On the
walls, blue sheets of paper, faded where they are exposed to the strong
sunlight: they are electricity bills. In the courtyard Lem is playing ball
with other children. He is wearing a black T-shirt with the picture of
a Thai actor, hero of a science-fiction film. The guests arrive, bearing
gifts. The future novice's kit is laid out on the mat, the robe, the beg-
ging bowl, a blanket, a mattress, a mosquito net and, wrapped in sheets
of orange plastic, biscuits, instant chocolate, sweets, soap, toilet paper,
toothpaste, packets of fruit juice, a razor, notebooks, pencils. It's the
home with its traditions, its smells, its flavours, that will try to follow
him to his new abode. Lan has just come in, bringing on a tray the of-
fering to the spirits, the *khuan*, which represent the innermost reality of
a human being, the energy that enters his or her body at the moment of
birth, loses its balance during illness and leaves forever at death. Even
animals and objects possess a *khuan* and many times Lem, son-*khuan*,
the favourite, has prayed with his father to the spirit of the seeds, on the
edge of the rice paddy, begging it to bring a good harvest.

On the tray Peng has placed an egg, balls of rice, cakes, ripe bananas, a piece of chicken and some dried fish. Shortly she will begin the ritual of *su-khuan* to wish her son a happy entry into the monastery. And so the Banphasa, the Buddhist ceremony of ordination of a novice into the community, gets under way like this, in the heart of Animism, in the presence of these supernatural beings that will feed on the scent of fruit, meat and honey and will fly around the white flowers of frangipani and jasmine and the golden flowers of marigold. The master of ceremonies, the Achan, has arrived. His bicycle is next to Lem's, propped against the wall of the house. Lan calls his son, the ball rolls down the slope and other children run after it. Lem already knows everything. For a moment he goes into the house and gets undressed. His mother takes his clothes, those clothes that he will never put on again, then he goes out and this time it's his sister who calls him. She has to wash his hair, it's time. The men take Lem behind a hut. The women follow them, but remain at a distance. The Achan approaches, a razor in his hand. Slowly he begins to cut off Lem's hair, so clean that it shines. The noise of the blade scraping his skin can be heard. It hurts the first time, all the monks say so. The locks fall onto his cheeks, his shoulders, his knees and are rinsed away with water, perhaps along with his tears. The man stops. Lem touches his head, running his fingers over the bare eyebrows, as if to make sure that despite that cut, that loss, with the light now free to model his features, it is still him, and that it is the face he knows, as he has no mirror to look at himself in. Lem's father has to cut a few tufts too, and so does his nephew Pet. One last stroke, behind the ears, and it's finished. A girl hands Lem a plastic basket with a bit of soap, a sponge and his toothbrush. Running along a path lined with palms, bamboo and tamarinds, Lem reaches the bank of the river. The other children follow him and sit on a tree trunk to watch. Lem dives in, swims out and then returns to the shore to get the soap. He submerges himself, and then cleans his teeth. A little girl enters the water and tries to approach him, but she's small and the current pushes her past him. She tries again and the others call her out of the water. "Don't touch him", they tell her. One more dive, and Lem's head resurfaces like that of a snake, smooth and shiny. His body moves sinuously too, already in another dimension.

At home everything is ready. The guests are seated at the sides of the room, in silence. The Achan begins to wrap a white habit around Lem.

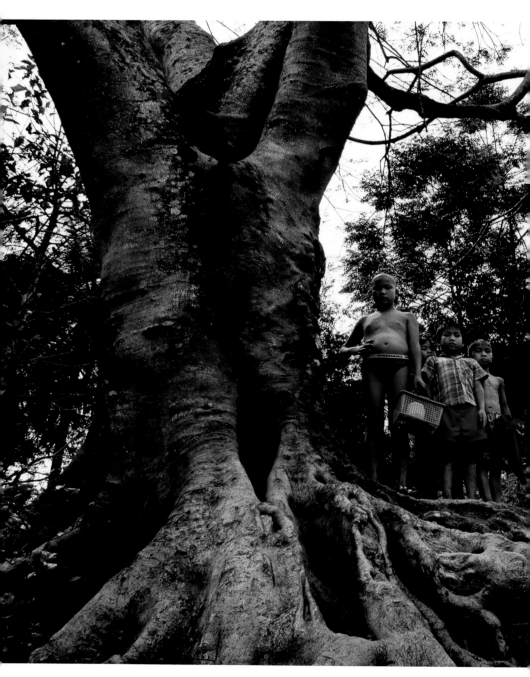

At the roots of knowledge.
Like many farmers' sons, Lem is entering the monastery to continue his studies. Before joining the religious community, the Sangha, the novice to be must go down to the river and wash away the last traces of impurity in its waters.

A woman hands him a pin, and after that last contact no female, not even his mother, will be able to touch him again. Lem has become a *nak*, an aquatic creature, descendant of the mythical nagas who are the protectors of Luang Prabang, able to change their appearance and take on the guise of human beings. His father, his mother, the master of ceremonies and Lem gather around the tray of offerings and place their fingers on it. The Achan begins to pray: "Little Nak, you are about to leave this house and this world. You are about to leave your parents to enter religion. By now you have discovered that all the things of this life are sorrow that imprisons us. They are fleeting, unreal, impermanent, oppressive, neither true nor good, subject to birth, ageing and death. In this moment you should be thinking of your parents, of what they have done for you, day and night, of their love from the time you were conceived to the months that you spent in your mother's womb. When you came into the world, someone washed you, others took a piece of cloth to cover you, after having cut the umbilical cord that tied you to your mother with a bamboo knife. Your mother hugged you and held you on her lap. Three times a day she fed you and three times a day she washed you. She has kept you close and has caressed you. And when the season of the new year arrived, when the rain and its deafening noise frightened you, she embraced you, she hugged you to her breast and she put you in your cradle. And when she nursed you, she gazed at you, her son more precious than any pearl. Then you grew, you started to run, to play, you became a man. And so you began to think about suffering, about difficulties, about anxieties. And for this reason you have become a monk. Father, mother, relatives, friends and believers are gathered here around you. They have brought the gifts needed for your entry into the monastery. May you be reborn in a higher heaven, reach Nirvana, obtain happiness, defeat sorrow, remain faithful to the Law. Glory, fortune, happiness, health! I now invite the *khuan* of this Nak to go back into him. If they have left, may they return! From dangerous places, from forests, from caves, from foreign countries, may they return forever to your heart and your body."

The prayer is finished. Lem is slipping away from this world, from his family, a little pearl returning to the water. The son bows, offers a bowl of flowers and incense to his parents. He thanks them. He says farewell. The procession forms. At the door of the house Peng has had time to

open the umbrella and hold it out to Lem, as if she were a branch of a mango tree that is bent under the weight of its fruit and is only waiting for a hand to pick one of them, the ripest and most sweet-smelling. But it is the Achan who gives him the umbrella. Any object is now a forbidden intermediary. The procession to the temple is greeted by the monk Boun, head of a tiny community of three novices. Lem, who left school a week ago without saying goodbye to his companions, Lem who says that he slept well last night, Lem the chrysalis bows three times and without drawing breath, his hands clasped at his breast, asks to enter the monastery. The Achan stands up, the young *nak* has to change his skin again and turn orange, a small incandescent sun that sets the air ablaze with every step. Bowing, Lem recites the formula of the "Three Jewels": "I take refuge in the Buddha, I take refuge in the Dhamma, I take refuge in the Sangha." To enter his new refuge, to become a *bhikkhu* among *bhikkhus*, a beggar among beggars, Lem has only to make a half-turn, like the half moon becoming full, rosy in the grey sky of this season, and sit next to his new master. The three novices make room for him, and then reform their ranks. Between Lem and his family, between a twelve-year-old child and his meagre past, an impassable river now flows. Those present look one another in the eyes; the women lower their gaze.

Lem has crossed over, onto the other shore. This evening the novice Lem will go to the *kuti* next to the monastery, to spend his first night away from home in a simple wooden cell. His father, his mother and the guests walk away. No one turns round.

The sky has grown even more overcast. A few drops even fall, but it is just humidity. Lan has turned on the TV, it's time for the news. In the opening sequence run old clips of the Pathet Lao, a meeting of the Komintern, a portrait of the president, roads and buildings under construction, and then the golden silhouette of the Pha That Luang, the stupa in Vientiane, a new symbol of national unity after the collapse of the Soviet Union and its emblems. The two satellite dishes in the garden pick up programmes from Thai and Vietnamese TV channels, soap operas and karaoke, but this evening Peng and his neighbours stay in the courtyard to talk. One of the women is going to get her hair cut tomorrow and get it permed, with curls. Everyone laughs.

The sun has risen. After the *tak bat*, the morning round of begging, Lem's family offers a meal to the monks of Wat Nam Nga. For a few

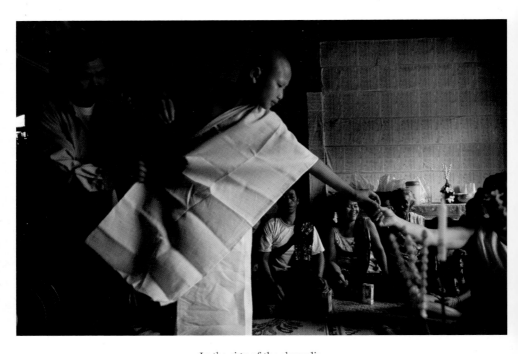

In the sign of the chrysalis.
The ceremony has begun and Lem puts on the white robe that will accompany him to the temple.
It is the first skin of a creature taking on a new form.

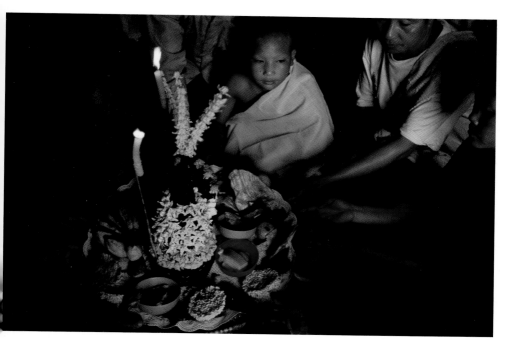

Spirits, come.
To protect Lem, and to infuse him with courage, the Achan invokes the power of the khuan.
On the tray of offerings, Animism blends naturally with Buddhism.

hours their son will come home. During the night his hair has started to grow again and on his scalp, so smooth yesterday, a darker shadow has appeared. Soon Lem will take his leave of the village and set off for Luang Prabang with his father. Peng has vanished, she doesn't even come out for a last goodbye. During the meal the monk Boun has spoken about one of the Buddha's previous lives, telling the story of Prince Visvantara, his wife Madri and their children. Disillusioned with wealth, the couple had left the royal palace and gone to live in the forest. One day, while Madri has wandered off to collect fruit and roots, the prince meets an old brahman, who asks to be given the two children. Heartbroken Visvantara agrees. On her return Madri, frightened by the silence of nature, discovers the truth and overcome with grief falls "like a liana cut off suddenly at the roots." The gift of one's own children, explains the monk Boun, is the highest gift of oneself, and as such will be rewarded. The children will return to Madri and Peng too will receive a recompense. In the mathematical division of sacrifice that regulates Laotian society, half of the merit that derives from the entry of a son into the monastery goes to the novice, a quarter to the mother and the other quarter is split between the father and the guests. It is the last homage to maternal love. From here on the law of men holds sway.

The car has come, Lem's journey has begun. A journey that resembles the one made by the Buddha, prince of the Gautama family. The Awakened One, son of a wealthy merchant, had also left home in search of new understanding. His father had baptized him Siddhartha, "he who has attained his goal." Lem, son of a farmer in the mountains, from the humble stock of the Vilaihong, is about to commence his own journey of understanding. Perhaps he too will find himself.

This house-life is pain, the seat of impurity.
An ascetic life is an open-air life.
So considering he embraced an ascetic life.
(Suttanipāta, 408)

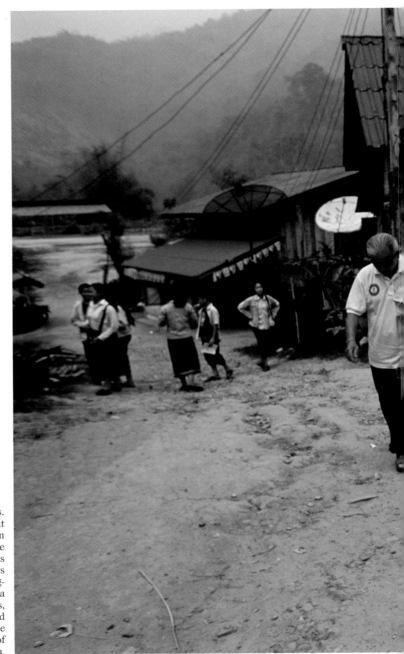

Precious goods. The procession that will follow Lem through the village forms in front of his house. Everyone bears a gift: the robe, the begging bowl, a blanket, a few biscuits, pencils, exercise books. And another book, the Dhamma, the word of the Buddha.

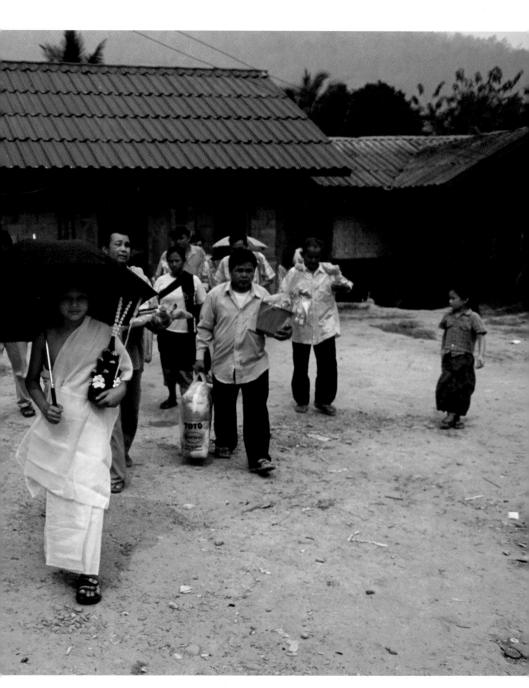

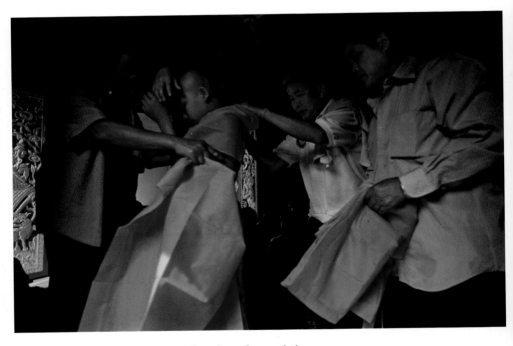

The colour of renunciation.
Wrapped in the orange robe, Lem pronounces his vows: "I take refuge in the Buddha,
I take refuge in the Dhamma, I take refuge in the Sangha."

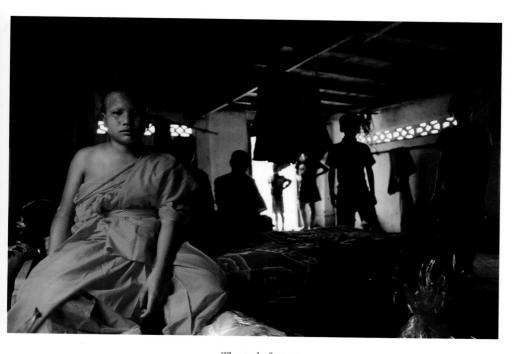

The end of an age.
They have always played together, but now Lem's friends keep their distance.
In the monastery cell, a child has ceased to be one.

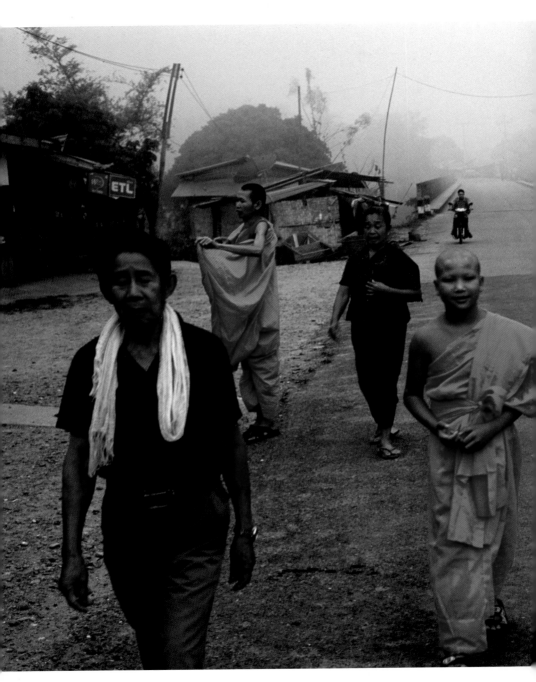

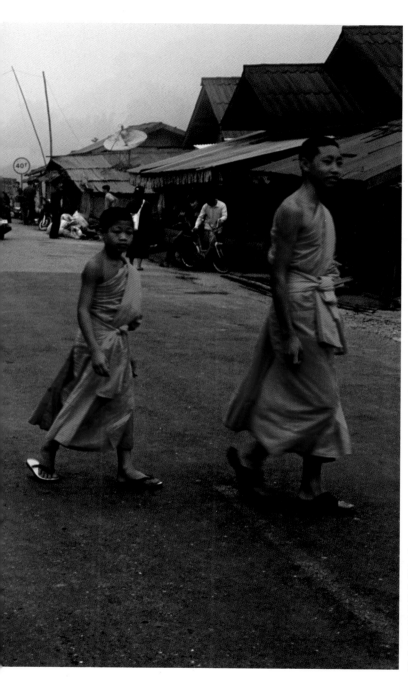

On his way.
At dawn, after the *tak
bat*, the begging for
alms, Lem goes home
for a few hours.
One more meal with
his family and his new
community. Then it
will be time for fare-
wells and a long, dif-
ficult awakening.

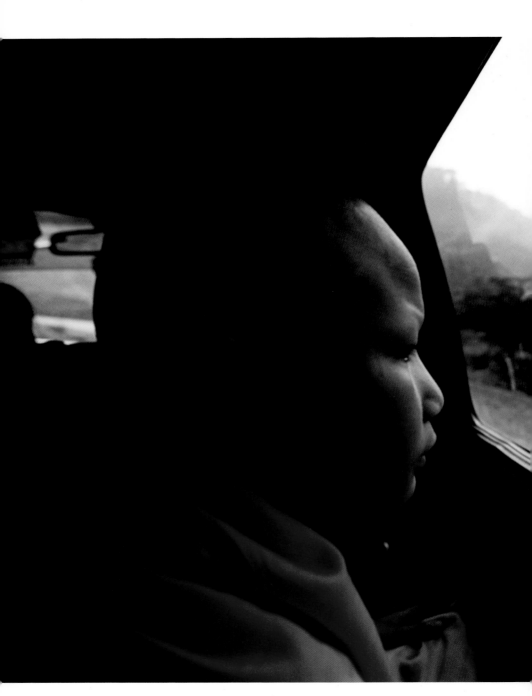

Towards the city of gold. One last look at his land, at his mountains, at his traditions. Lem will soon arrive in Luang Prabang, capital of Theravada Buddhism, the "Teaching of the Elders." Waiting for him, its most beautiful temple, Wat Xieng Thong.

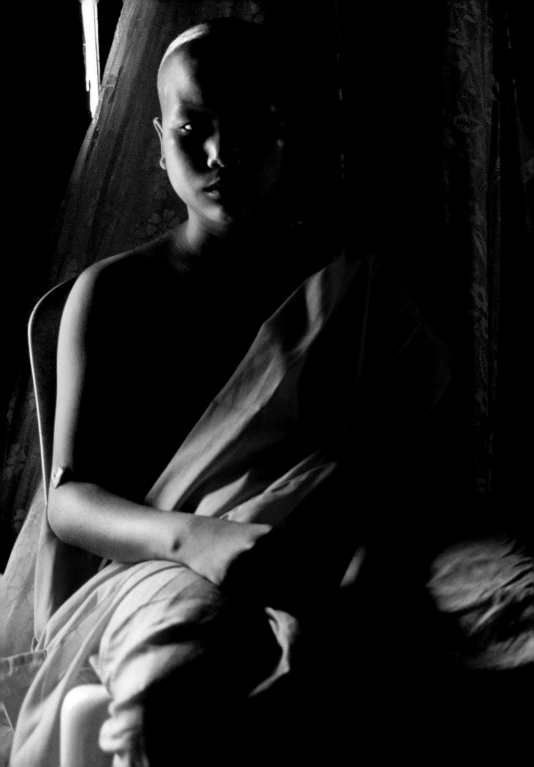

A New Home

p. 44:
Lem a few hours after his entry into
the community of Wat Xieng Thong.

Previous double page:
Separation.
Lem has arrived at Wat Xieng
Thong, symbol of Luang Prabang. In
his new cell, *kuti* in the Lao tongue,
the little novice starts to get his
bearings and in the darkness of his
thoughts seeks a light to keep his
spirits up far from home.

During the journey, Lem remains silent. The monk Boun has asked him not to speak until they get to Luang Prabang, but instead to wrap himself in reserve, as if it were another robe he had put on, more intimate than the first. Taking leave of his young pupil, while the other novices walked towards the temple, the master had explained to him that vow: "Novice Lem, listen to what the Buddha tells you: O monks, you are my sons, my direct descendants, born from my mouth, born from the Dhamma, heirs of the Dhamma and not of material things. Novice Lem, now that you are leaving your family, let these words accompany you to your new home. Do not mix them with others, and make your body their casket." In the car, so as not to lead Lem into temptation, no one speaks. Lan rests his head against the window and shuts his eyes. Last night he had difficulty falling asleep.

The road grows wider, the river that ran alongside it has vanished, behind a bend. Even that last tie, that last link between Lem and his world, has been severed. If he had ever set free one of the fish that he used to catch with his father in those same waters, begging it to return the favour in another life, then perhaps the little monk would have been able to put his childhood behind him without sorrow. Magically, among the black flickers of the asphalt, a little fish might have appeared, and Lem would have taken it in his hands, bathed it with his silent tears, and it would have accompanied him to the monastery, relieved, at peace. And every evening, to renew the enchantment, the novice would have gone down to the bank of the river, waiting for that strange creature to bring him news of home. If only he had had pity. If only he could believe in fairy tales, even now.
Along the way the first billboards appear: an invitation to join the army, a mural celebrating the union of workers, farm labourers and scientists in white coats, one next to the other. And finally the advertisement for an insurance agency: a house on fire, a family screaming as they flee, better take out a policy.

Lem looks at his father, who has just woken up. By now they have

The door of
knowledge.
At the entrance of a
kuti at Wat Sop, the
small community of
novices, aged from
twelve to eighteen,
has hung some
prayers to memorise.
They are written in
Pali, the sacred lan-
guage of Buddhism.

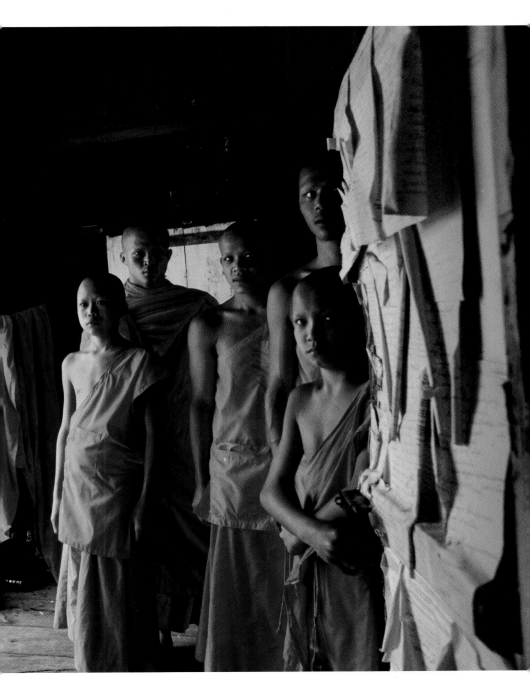

reached the outskirts of Luang Prabang. A deep breath and they start to talk again. The window frames a football pitch, now occupied by a fun fair, but it is daytime and the attractions, including an enormous whale with a gaping mouth, are closed. Higher up on the hillside stands the white profile of Wat That Luang, the monastery of the great stupa. Lem's grandmother used to tell the story of how, as a child in the fifties, she had attended the funeral of one of the members of the royal family held in this temple, and her description of the flames that rose into the sky, of the drums, of that procession of hundreds of the faithful, the entire city kneeling before the coffin to pray, had caught the imagination of all the children. In part, the old woman had told them, because that monastery had been built where there had once grown a forest of strongly scented lemon trees, the abode of an ogress called Nyakhinee, who used to devour human beings. One day, as her daughter was tired of playing by herself, the monster carried off twelve girls who were wandering in the forest, abandoned by their parents, a poor woodman and his wife. They were beautiful but too skinny, and so Nyakhinee decided to put off the moment at which she would eat them. Leaving the prospect of that terrible meal in suspense, Lem's grandmother went to bed, putting off to the next day the end of the story, when the girls managed to escape and eventually married a king, and there was the whole night to imagine their plans, their whispered words, their fear, and then the anger of that terrible creature.

Lan has stopped in front of a fruit stall. Time to buy something for the offering to the temple. A few minutes more, along the road that the monks take every day for the morning round of begging, and the car arrives at Wat Xieng Thong, at the confluence of the Mekong and the Nam Khan. In the cell assigned to Lem also live his brother Sou, his cousin Ngock and a novice from Muang Sing, in the north of the country. Each has his own space. In the pecking order that holds sway in the room, Lem is still an outsider and his things are left in a corner until this tiny community re-establishes its equilibrium. Lan has completed the move. He'll spend the day with his sons and leave tomorrow, at dawn.

It's half-past eleven and the monks bring into the central hall the dishes for the second and last meal of the day, as is the monastic rule. The drum is sounded and the novices flock in from the temple, the cells, the

kuti, looking like streams of orange mercury flowing back to the source. The man in charge of the temple invites the brothers to pray. They eat in silence, seated on the ground. Lem is in a corner, close to a lattice of white wood, as if he were looking for one safe wall to lean against and another, open one, from which to watch the foreigners, wandering tiredly around the sweltering temple yard. Through the holes in the lattice, drawn by the smell of food and equally devoted to the rhythms of the temple, enter two cats. Only they move around freely, picking their way among the folds of the robes. They are allowed to touch the inviolable, curling up between the monks' knees, begging to be stroked and sniffing the fingers that offer them a piece of fish. The meal over, Lem leaves a little broth in his bowl and the cats carry on eating undisturbed. His mother too, at home, used to do the same.

A few days before his departure, a family friend, Mr Sone, had talked to Lem about his youth spent in Luang Prabang, in the sixties. He had been a novice at Wat Mai, one of the most beautiful temples, with its golden wall that speaks of perfect harmony between heaven and earth, between men and the Buddha, between the beasts of the fields and the forest. Buffaloes and tigers together, the most patient of animals, the docile force that helps man in his labour, and pure ferocity; and Mr Sone had also spoken of the *saming* tigers, evil creatures able to take on human guise and devour even the most skilful hunter. "I was a little boy when I arrived at Wat Mai and at the time life in the monastery was not so different from outside. There was nothing for anyone and no one wanted anything. I slept behind the great statue of the Buddha. I only studied the sacred texts, the canon, and it was enough for me, not like now. For you it is more difficult."

When Lem was small, just one family in his village had a television set and anybody who wanted to watch it, neighbours, relatives and friends, had to pay something, the price of a ticket like at the cinema. Then Lan too had saved up and managed to buy a TV, and his son had discovered Thai science-fiction movies.

At Wat Xieng Thong, in the room next to Lem's, the novice Tulin has hung up a poster of Bruce Lee. Lee is his favourite actor; at home he never missed a film and used to repeat the most famous lines to his friends. He has written one of them on the wall of his cell: "To change,

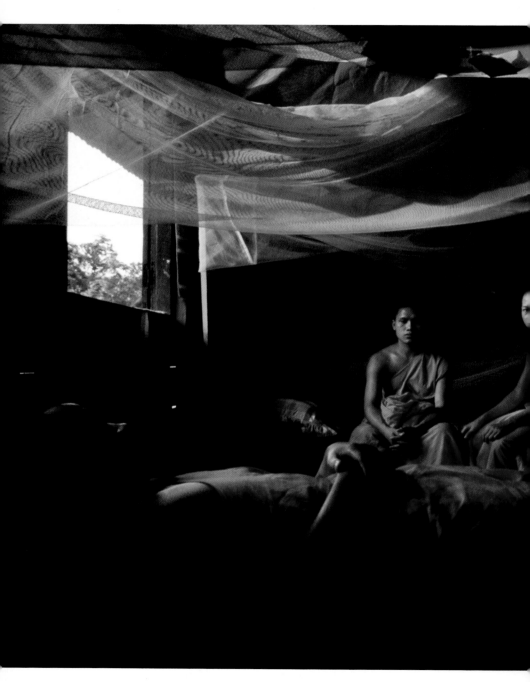

Waiting.
In the late afternoon, when the sun's rays penetrate the darkness of the *kuti*, three novices of Wat Paya Theup, the temple of the crematorium, rest while waiting for evening prayers.

we have to know who we are." On the same wall, as if to justify this alien presence and associate it with a more noble source of wisdom, Tulin has inscribed a maxim of the Dhamma: "Spur yourself on, control yourself, and being aware, o monk, you will dwell in peace." For a moment, among the reverberations of the hanging robes, Kung Fu illuminates the Law. And Tulin, sixteen-years-old, explains to Lem where to find the strength to keep the commandments of the Buddha. Lem listens, seated on the bed, while Tulin's eyes play over that badly knotted robe, the mark of someone who has not been long in the monastery and not yet experienced hunger in the evening, loneliness, homesickness, the sudden desire to run, roll about, jump and even love. That desire for bursting, unbridled energy, like a fire spreading through dry leaves.

Lem knows nothing yet. Today Tulin is his teacher and takes him to another temple, to Wat That Noi, where a friend of his, Khamdee, lives. Another cell, another means of escape.
"When I arrived in this *kuti*", recounts Khamdee, who has greeted Lem with a warm smile, "the walls were covered with cuttings from magazines, pictures of girls, actresses, football players, singers. So I took blank sheets of paper and pasted them on top. I wanted a clean space to concentrate and meditate." But one day, on that white shell, some words in English had appeared: "nothing is difficult to a man fired by his ambition." And then another one, "LOVE", written in capital letters, in red. And Khamdee, who wants to become a surgeon and knows how to cut into the flesh of reasoning, explains that English is like the Pali of two thousand five hundred years ago. "Then too the followers of the Enlightened One chose a common language to convey the message of their Teacher." A vernacular, in order to become a community and discover the straight and narrow path together. This is what Pali was and this is what English is today, in Laos, a language to open up the borders of the country and go beyond the limits of this natural monastery, closed for years to foreigners, and with which to learn, discover and compare. Then the time will come, for Khamdee, Tulin and Lem as well, to withdraw into themselves, into the immense space of their consciousness, and to embark on another journey that will take them even further. And they will have no need of images or words borrowed from others, but everything will already be there inside them.
In the cell next to Khamdee's live the Tao brothers. Their father has

come to see them, as he does every month. He belongs to the Hmong people, who are Animist, but has entrusted his sons to the Buddha so that they can study. The youngest, Tin, is twelve and will go to school with Lem. And Lem, for the first time since he has come out of Wat Xieng Thong after lunch, finds the courage to ask a question. "Tin, what do you miss most?" And Tin answers, "my mother's chilli sauce." "And what do you miss about your mummy?" asks his father. "I miss when she used to wash me, dry me and dress me in clean clothes."

At sunset the drums start to sound again, it's almost prayer time. Tulin and Lem quicken their step and go back to the temple. Lan joins his son and to help him cope with the fast will also not eat this evening. They chat under a tree, in front of the monastery. The flowers have a very sweet fragrance that seems to become visible in the damp air of the sunset.
The novices go back inside and start to lay out the mattresses. Lem opens his mosquito net and slips inside. His father lies down next to him. A few more words, and then the novice in charge of the room turns off the light and the bluish reflections of neon disappear from the walls. Yesterday evening, the monk Boun had wished Lem goodnight with these words: "A young monk who puts into practice the teachings of the Buddha illuminates the world like the moon coming out from behind a cloud." For another few seconds, in the darkness of the room, the glow of the computer screen can still be seen and then, with the same jingle that announces the shutting down of operating systems all over the world, this turns black too.

The day starts at five o'clock and through the windows, left open at night as well, wafts the smell of rice cooking in the nearby houses. The same novice who imposed the curfew turns the light back on. Lem goes on sleeping and, first with a whisper and then with a laugh, his father wakes him. Lem looks around him and only now does he realize that above his head flows a magnificent waterfall and that farther on the waves of the sea lap on a beach in Thailand: two posters hanging on the wall. His fellow novices have gone down to the courtyard to wash themselves and their begging bowls. The *tak bat*, the time when they go out to beg for food, will start soon, and soon too Lan will be going home. For a few seconds father and son sit in front of one another, motionless, and this calm, this serene acceptance of fate, comforts them both.

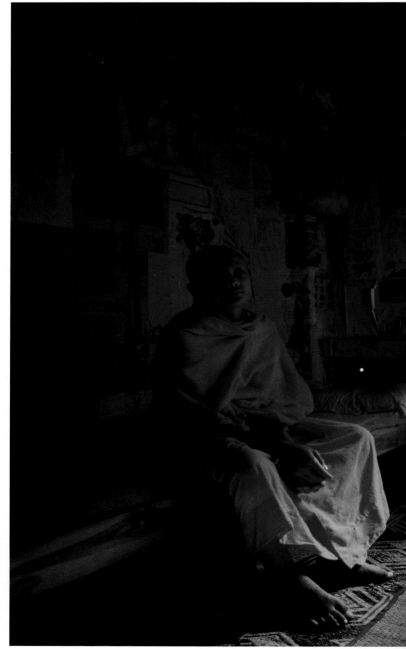

Power to images.
Pages of newspapers,
adverts, calendars,
drawings, and the
omnipresent image
of the Buddha. In the
kuti of two novices
at Wat Aham, daily
events merge with the
rhythms of faith.

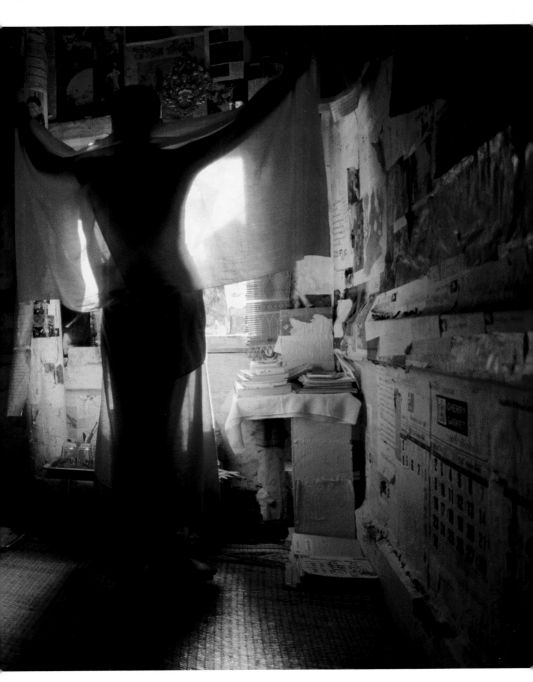

"Life is short" someone has written in English in Lem's cell, for in this life there is no time to drag your feet. On a piece of cloth painted miraculously by the light of the Buddha, as the life of the Enlightened One relates, are written the words: "O monks, apply yourselves tirelessly. Give up worldly life and devote yourselves to the teaching of the Buddha. Destroy the forces of Mara, as an elephant would trample down a reed hut. He who lives with watchfulness and diligence in accordance with the Dhamma and the rules of the discipline, will put an end to suffering." Lem's first rebirth has begun. But suffering, quiet and composed, remains by his side, for a little while yet.

A monk with his mind at peace,
going into an empty dwelling,
clearly seeing the Dhamma aright:
his delight is more than human.
(Dhammapada, 373)

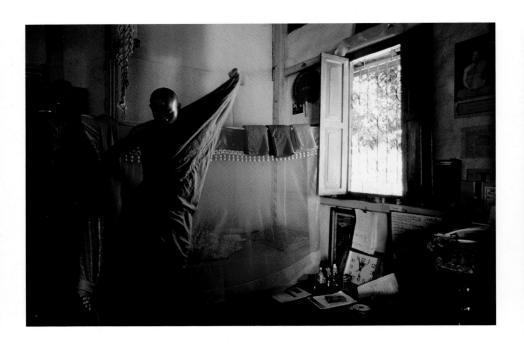

Suppleness.
This too is a sign of devotion. In his cell, the monk Go, head of the community of Wat Ho Sieng, wraps himself gracefully in the folds of his robe.

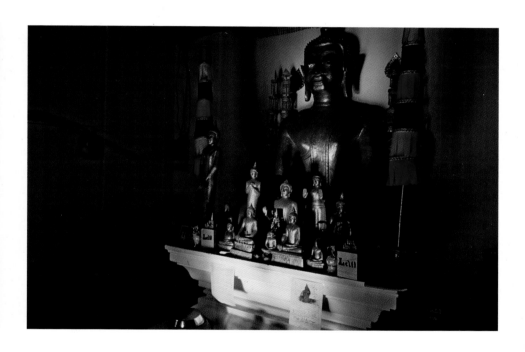

On line.
Next to the altar of the Buddha, a novice at Wat Pa Phay has made himself a corner for
study and the blue glow of a computer can be glimpsed amidst the gleaming statues.

With lowered eyes. This is the rule in sacred art, and what modesty suggests. In a *kuti* of Wat Si Boun Houang, a novice recalls the gaze of his Master and without uttering a word lets strangers continue on their way.

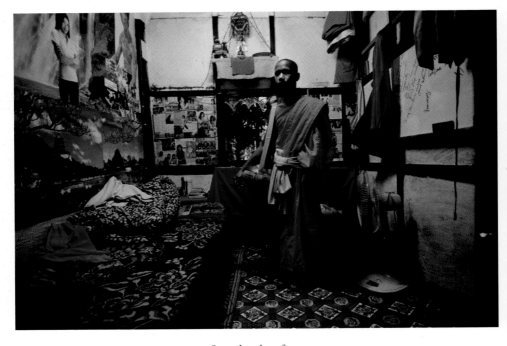

Sacred and profane.
The Buddha and Bruce Lee, prayers and Kung Fu. Next to them the stars of Thai cinema.
The cell of a novice at Wat Xieng Thong, devoted to nostalgia for his life as a boy.

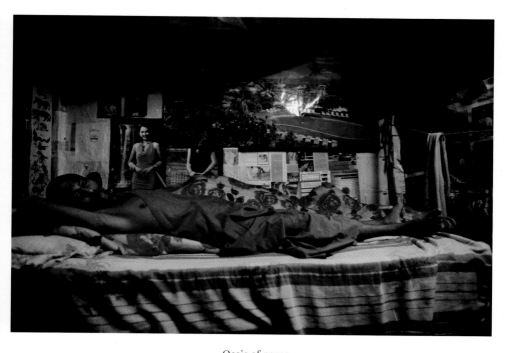

Oasis of peace.
This tiny *kuti* at Wat Si Boung Houang becomes as wide as the ocean.
On the horizon, a girl's smile and an advertisement for a resort in Thailand.

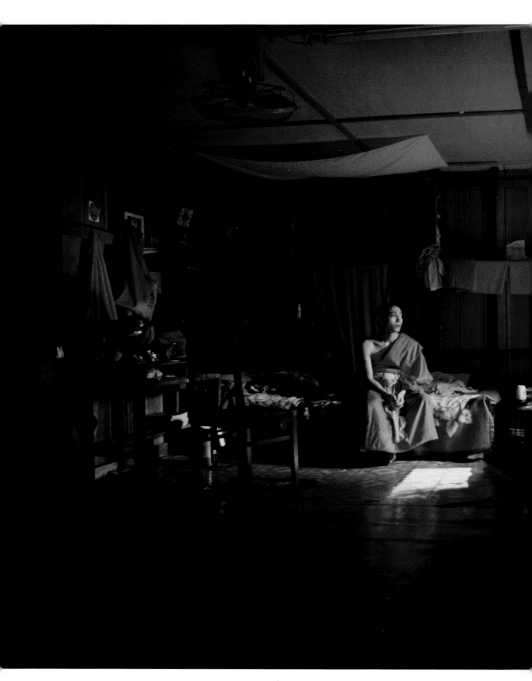

Garage.
A refuge for the soul, the body and the few possessions that accompany the life of monks and novices. But in this simple *kuti* at Wat Pa Khe there is room even for the English teacher's motorbike. He too is a former monk.

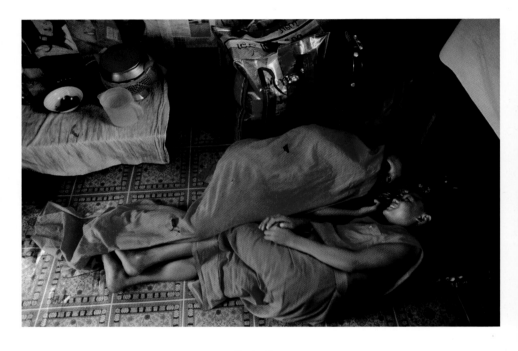

Protection.
They come from a mountain village. Cousins and novices.
United by a common destiny, affection and a small cell in the temple of
Wat Si Boun Houang.

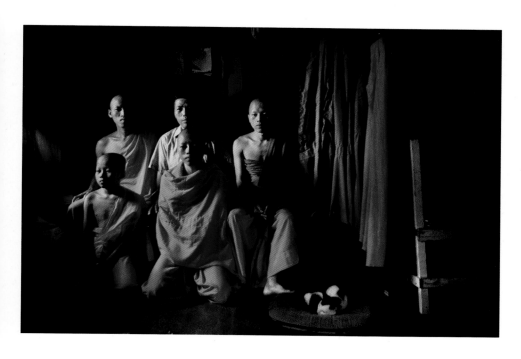

Parents.
The Tao brothers live in a cell at Wat Ho Sieng. Their father, who belongs to the Hmong ethnic group, is an Animist but has placed his trust in the Buddha for the future of his family.

Innocence. A summer's day. In the heat of the early afternoon, a novice lies exhausted on his bed at Wat Phone Sai. Maybe he doesn't realise that he has committed a sin: pointing the soles of his feet towards the sacred image of the Buddha.

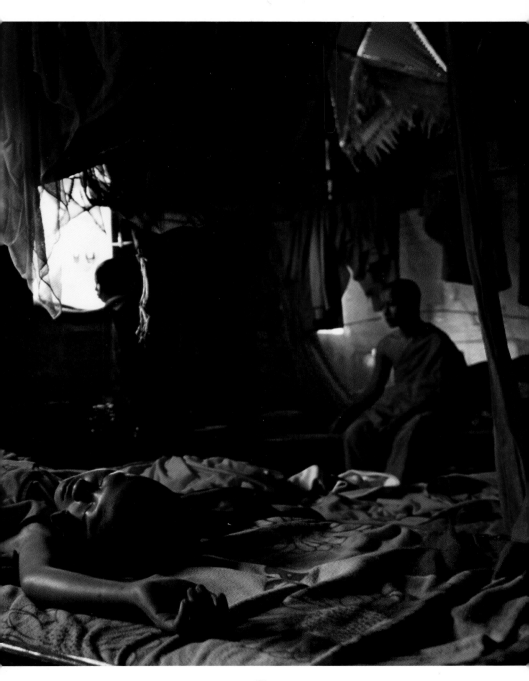

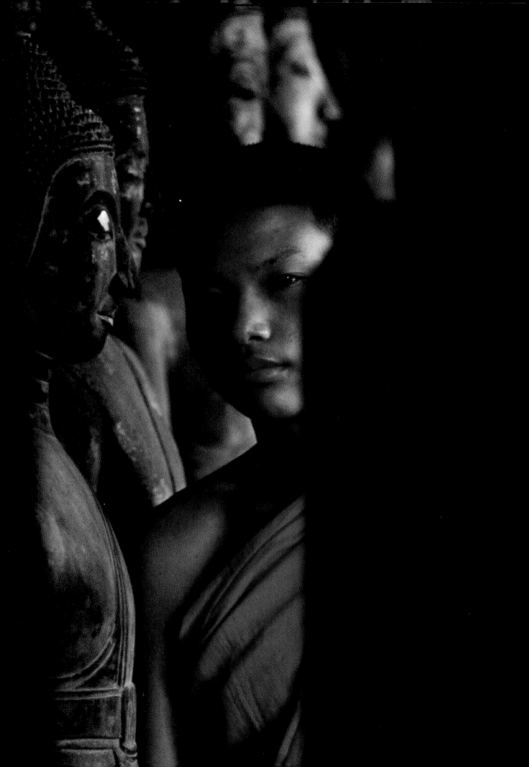

The Temple

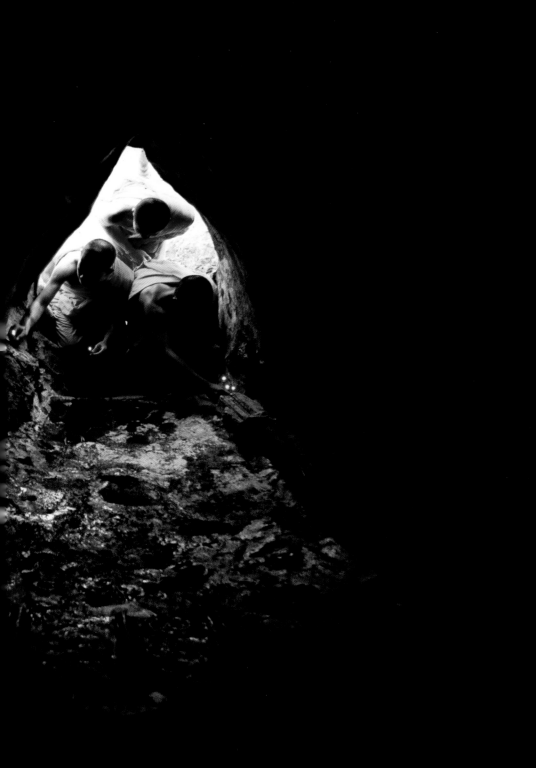

p. 74:
Lem among statues of the Buddha at
Wat Vixun.

Previous double page:
Tracks.
In the cave of Wat Phraphoutthabat,
a stone's throw from the Mekong,
gleams a footprint of the Buddha.
On this same riverbank, the
mission of Maha Pasaman, a
Cambodian monk summoned to
convert the people of Laos, landed
in the 16th century.

Lan gets home in time to see his wife folding up Lem's clothes and handing them over to another woman, as if those jeans, those T-shirts, now belonged to somebody else, and no longer to her son. Lan stands and watches, with the impotence of someone who has no part to play in a ritual. Then he goes up to Peng and, as if wishing to cheer her up, hands her a package wrapped in newspaper. On his way back, in the market just outside Luang Prabang, he had bought two gilded plastic frames, made in China, for the photos of Lem: one shows him alone on the steps of the temple, already a mendicant, with the begging bowl hung over his shoulder, and the other is of the three of them together, arms by their sides, in the pose which in statues of the Buddha indicates waiting for rain and in mortals a posture free of rigidity, without hierarchies. Everyone is equal, standing before life, like a murmured exclamation.

Peng has placed the photographs by the television set.

Tulin and Lem's cousin have been summoned by the prior of Wat Pak Khane. Along with other novices, they will go to bless the construction of a bridge. Lem is too young. He doesn't know the liturgy yet, and stays at the temple. He is alone. The cell is empty. In the blazing light of midday, nothing belongs to him, and none of the magnificent temples whose glistening forms rise among the gardens of the city can give him comfort. Not even Wat Xieng Thong, which is radiant in its splendour and seems to have been made on purpose, with its golden paintings on a black background, to sweep away feelings of gloom. After lunch, when only the cicadas are still awake and the dogs have taken refuge under the bushes, Lem decides to go down to the river. But instead of the imposing flight of steps where the king and his court once used to land, he prefers to take a path that soon softens and turns into mud. On the bank a strange moving carpet appears. It is made up of hundreds of worms that poke out of the sand and wave their thin bodies. Lem has to be careful not to tread on them. It's one of the commandments that he has sworn to obey: to have compassion for all living things, even worms. Not far away a little girl, free of all such obligations, is laughing as she collects those strange

Heavenly flowers. The gold decorations on the roofs of the pagodas of Luang Prabang recall Mount Meru, the mythical axis of the world. Bringing us back to earth, Lem's face appears among the glass mosaics of the Red Chapel of Wat Xieng Thong.

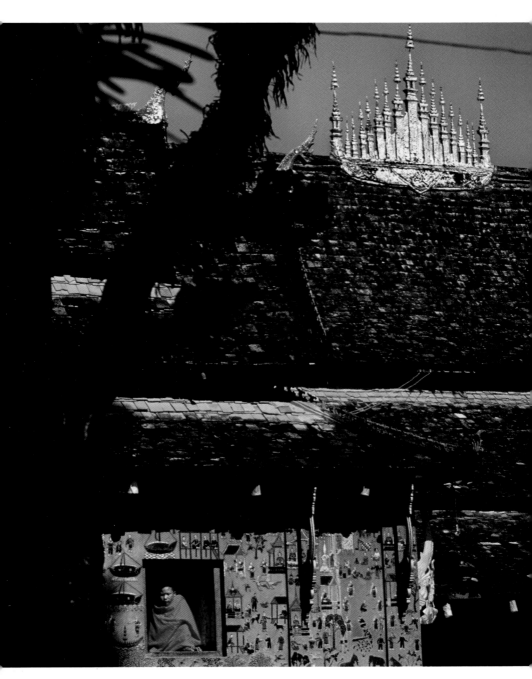

blades of grass and puts them in a jar, shaking it every now and then with innocent cruelty.

Lem sits on a rock. It is so hot that the water is turning into vapour and the mist drains the colour from every form. "In the sky there are no tracks", it is written in the Dhamma, for to the sky belongs Nirvana, the end of all desire, of all suffering, the void, and no one knows the words, tracks of the voice and the hand, to describe it. On the earth instead Lem will have to follow new tracks to find his way. At home, his mother too is looking for other paths, in the rooms of the house, in the yard, along the road that leads to the village and its school, paths on which she won't encounter ghosts.

On the opposite bank, three novices are waving their arms and shouting, trying to attract the attention of a boatman: they have tied up their dugout badly and it has drifted off, and born in the most remote mountains where there are no streams but only forests, they don't know how to swim. The boatman makes a long turn, the motor strains against the current, the boat approaches that wretched craft and the passengers on board, a man and a woman, grab hold of it with difficulty and slowly draw it towards the bank. One of the monks wades into the river, up to his knees, up to his waist, and recovers his boat.

Waves ruffle the water and Lem's reflection moves like a snake coming to the surface, approaching the feet of that strange figure and then sinking to the bottom again. It is even possible to imagine powerful nagas lurking in those cloudy and murky depths, those mysterious beings that had assisted Lem in becoming a novice and that according to a legend had appeared to two hermits, the first to arrive on these shores, lapped by the Mekong and its tributary, the Nam Khan. An enchanted place, favourable towards men, to the gods, to fruit, to trade. A magical place to establish the capital of a kingdom.

On the tip of the peninsula – according to one of the myths surrounding the origins of Luang Prabang – grew an immense "flame tree" with splendid red flowers, known as *thong* in the Lao language. The hermits laid a stone at its foot and another on the bank of a stream, the Nam Dong. To the fifteen nagas that had emerged from the river and assumed human guise, the monks predicted that one day a city, called Xieng Dong Xieng Thong, would rise between those two points. The nagas were giv-

en the task of watching over and protecting it. And Wat Xieng Thong the honour of the honour of recalling the roots of the prophecy in its name. In a few weeks Lem will be going back to school, but before immersing himself in the dates of the sovereigns who ruled Luang Prabang for centuries, heaping it with riches, abandoning it because it was insecure and then taking it back again because they could not resist its charms, the little monk has time to remember another story, and to believe in it so as to make himself feel better, more fortunate, as if he too had been chosen. Preparing him for his entry into the monastery, it had been the monk Boun, who had told him of an extraordinary journey which took the Buddha and Ananda, his most beloved disciple, to Luang Prabang. Faced with such beauty, the Enlightened One smiled, and on seeing those slightly parted lips and those eyes lowered because of their knowledge of the future, the sky was flooded with light. When Ananda asked him the reason for that sign of joy, the Buddha replied that one day a marvellous kingdom would arise in that place.

"In reality", the monk Boun had said, "the Buddha never came to Laos, but his footprints are there all the same, and bowing over one of them, Lem, you should pray in the tiny cave of Wat Phra Bat Tai, light a candle and watch how its glow picks out the traces of gold that mark the outline of our Master's foot. Soon Lem, you will learn that, just after he was born, Siddhartha took seven steps, symbolic of his dominion of the universe, and that once he had achieved enlightenment the Awakened One left his footprint on a stone and many others followed marking the journey of Buddhism and its glorious march. And remember too that the first delegation of Buddhist monks arrived at Wat Phra Bat Tai. Sit on the viewpoint that overlooks a small creek on the Mekong River and imagine the landing of a boat. It came from Cambodia, where our first king, Fa Ngum, had grown up."

Lem liked to remember this journey, especially in the version recounted to him by his grandmother. Every time her grandson lost a milk tooth and went to her with the proof in his hand he was growing, she would tell him the story: "Fa Ngum was born in the year of the Dragon, and he was born with thirty-three teeth. The court shamans saw this as a bad omen. So the king decided to have a raft made and to abandon his son, protected by his most loyal servants, to the current of the Mekong.

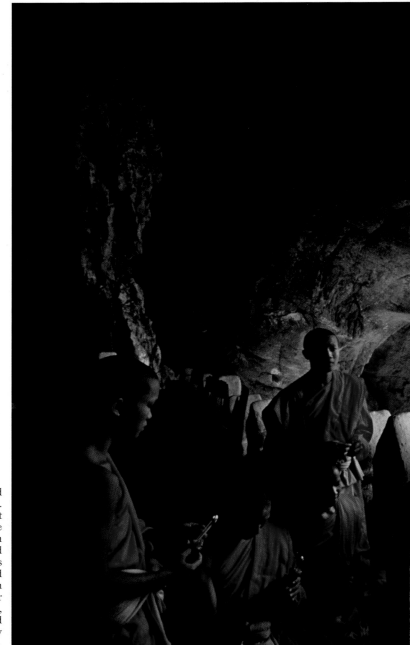

Four thousand Buddhas. The Pak Ou Caves, at the confluence of the Mekong and the Nam Ou, have housed thousands of statues of the Enlightened One since the 16th century. A popular and moving practice, to which Lem and his companions pay homage.

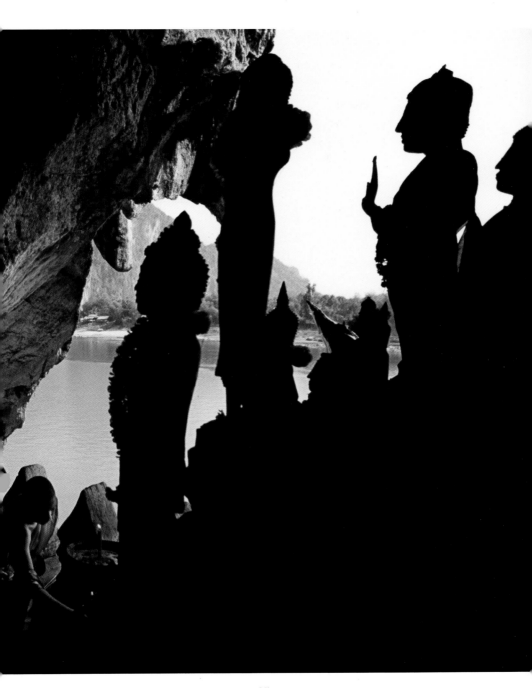

One day, on the border with Cambodia, the craft was spotted by the monk Maha Pasaman, who rescued the child and raised him, teaching him everything that a future sovereign should know. Then he took him to the Khmer court, where he grew up strong and brave and married the king's daughter, Princess Nang Kaew Kaeng Nya. When Fa Ngum received the news of his father's death, he set off with an army of ten thousand men to conquer his kingdom, reunifying it and giving it the name of Lane Xang Hom Khao, the Land of a Million Elephants and a White Parasol. And then a miracle took place: Maha Pasaman appeared to his disciple and begged him to spare the lives of his prisoners. The king was moved and complied with his master's wishes. But it was the queen who summoned that enlightened monk to Laos, unable to bear the dissoluteness of the court and a population that worshipped only spirits. Maha Pasaman ascended the Mekong, bringing with him the holy scriptures, the Tripitaka, and the statue of the Phra Bang. When he reached Viang Kham another wonder occurred: the statue became so heavy that it could no longer be moved, a sign that it did not wish to continue its journey. But the mission went on to Luang Prabang, and since then the Buddha has shown us the way. When Fa Ngum left the court again, setting off to conquer new lands, the throne passed to his wife, three months' pregnant at the time, and on the king's return the queen gave birth to a son, called Oun Heuane, which means 'Happiness of the House'."

Lem's grandmother did not know the date, 1353, of the reunification and birth of Laos, or 1358, that of the arrival of Maha Pasaman and the official advent of Buddhism. So it was the monk Boun who took up the tale and recited a litany of the names of the rulers of the ancient kingdom. "On the queen's death, Fa Ngum fell into all sorts of cruelty and was exiled from the kingdom. He was succeeded by Samsenthai, a devout man and a true Buddhist sovereign, and it was he who had the first pagodas built, including the beautiful Wat Manorom, 'the Monastery of the Great Heart'. Then Vixun became king, spreading the study of the Dhamma and ordering the transport of the statue of the Phra Bang to the capital. And this time the statue accepted the invitation and was housed at Wat Manorom. Then it was the turn of Photthisarat, who in 1525 was the first king to become a monk during the three months of our Lent, and as a fervent Buddhist had the altars of the guardian spirits

destroyed. Photthisarat was succeeded by Settharhirat, who decided to move the royal palace to Vientiane, as it was less exposed to enemies. The court left, but the Phra Bang remained to defend his subjects and for this reason the king decided to rename the capital Muang Luang Prabang, the great city of the Buddha Prabang. And in 1560, to compensate it for the loss of royal prestige, he gave it a magnificent temple, Wat Xieng Thong."

"But who were the enemies who threatened our country?", Lem had asked the monk Boun, for that part of the story had been left in suspense.

"At that time they were the Burmese, then came the Thais, the Chinese, the French, the Japanese, the Vietminh, the Americans and finally the Vietcong. They have all passed through. We have remained."

If one day Lem should wish to relive the march of the soldiers of the Pathet Lao, the Laotian communist party, and their arrival at Luang Prabang in 1975, then he would not have to stray far from his cell. It would suffice for him to go to the main street, Rue Sakarine, walk down to Ban Khili, one of the finest residences in the city, with its veranda adorned with orchids, shells and paper stars, and listen to the words of the mistress of the house, Ba Kambai. "I was born in 1929. My father was governor of the province of Oudonxay, in the north, but I studied in Luang Prabang. My temple was Wat Khili, the 'Monastery of the Golden Mountain'. I used to go there to pray every day, and I prayed for the Buddha to guide us with his immense compassion and help us to bear all our suffering. I've seen many wars, I've seen French rule, the arrival of the Japanese in 1945, the return of the French, independence in 1953, the Americans and finally the communists. I remember their entry into the city as if it were yesterday. The drums of the temples had warned us. No one went out, we were terribly afraid. The city was completely empty. Even the dogs had vanished. Then, once they had seized power, the Pathet Lao closed the monasteries. Only three were left open, Wat Xieng Thong, Wat Sene and Wat Manorom. But we couldn't go to see the monks, nor make them offerings. If the police saw two or three people together they would arrest them and the population was even supposed to denounce one another. But the communists were frightened too, and refused our food because they were afraid of being poisoned. They terrorized us in every way. One morning they took my father away. I was making breakfast and when I went into his room

Flames.
On the opposite bank of the Mekong to the city, the majestic Flamboyants, or Flame trees, grow. Following their splendid blossom, two monks make their way to Wat Chom Pet, the "Diamond Monastery."

he was no longer there. I never saw him again. If I hadn't found peace in the temples and in Buddhism I'd have gone crazy. Buddhism is our inner strength."

A pickup truck full of monks passes by under Ban Khili. The ceremony at the bridge is over and the inhabitants of the two villages, which will soon be joined by that narrow walkway, have offered the novices fruit juices and little cornucopias made of banana leaves, from which protrude sticks of incense, a candle, a banknote and flowers that are already fading. The Dhamma tells us: "Just as the jasmine sheds its withered flowers, so should you monks shed attachment and aversion."

Lem has moved away from the river and climbed back up. In the distance he sees Tulin and his cousin crossing the temple yard, a blue plastic bag dangling from their fingers. He joins them and together they reach the steps of Wat Xieng Thong. In the gentle unfolding of its wings, the monastery seems to be greeting the arrival of the evening. A star has appeared in the sky. There is an air of peace.

In 1887 Luang Prabang was invaded by Chinese mercenaries, the terrible Black Flags. Their leader, Deo Van Tri, ordered the sack and destruction of every temple except one, Wat Xieng Thong. As a child, he had been a novice there.

The footprints of the Buddha
are like a great mirror
in which the whole world is reflected.
(Pajjamadhu, 8)

The tree of life and of enlightenment. Nourished with prayers by Wat Xieng Thong, amongst its branches and glass flowers fly the kinnari, creatures that are half-bird, half-woman, a symbol of grace and beauty.

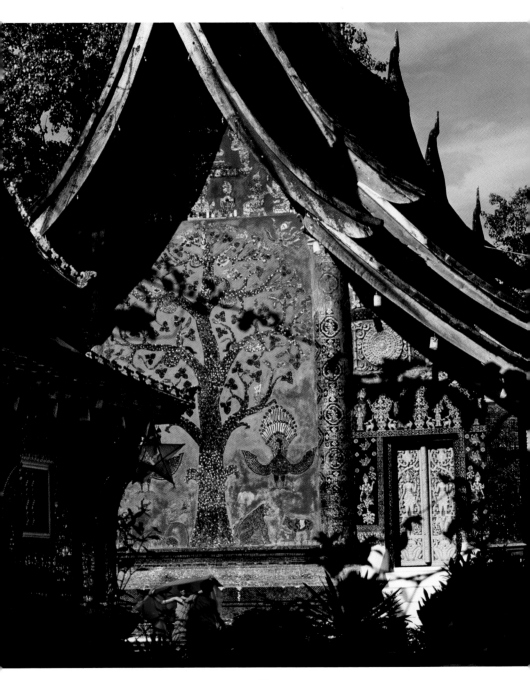

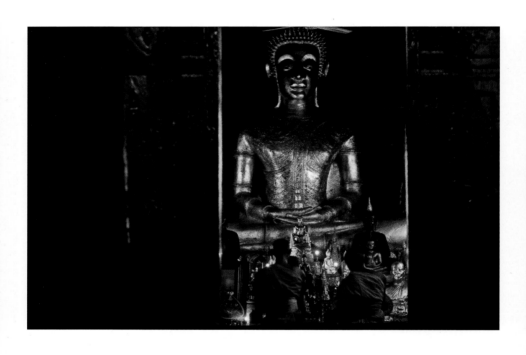

Listening.
In the stillness of meditation, the magnificent Buddha of Wat Mai receives his disciples at dawn, for the first prayer of the day.

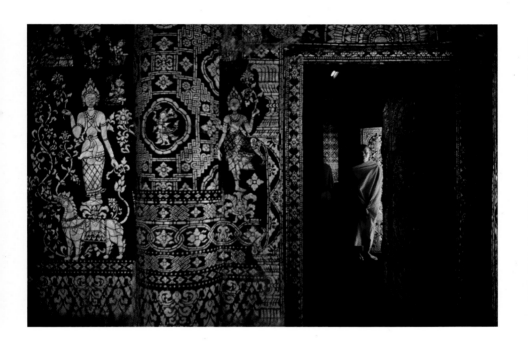

Threshold.
An army of mythical creatures marks the entrance to Wat Xieng Thong. A warning against the temptations of everyday life. An invitation to enter another dimension.

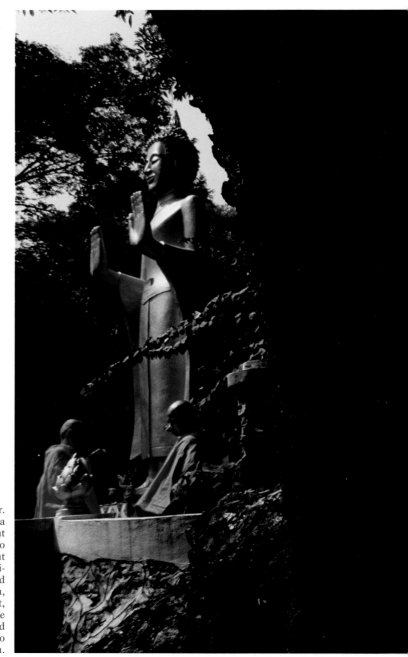

Do not fear. Statues of the Buddha gleam along the flight of steps that leads to the summit of Mount Phou Si. Each position, a teaching. And with his hands open, palms facing out, the Enlightened One drives away fear and indicates the way to salvation.

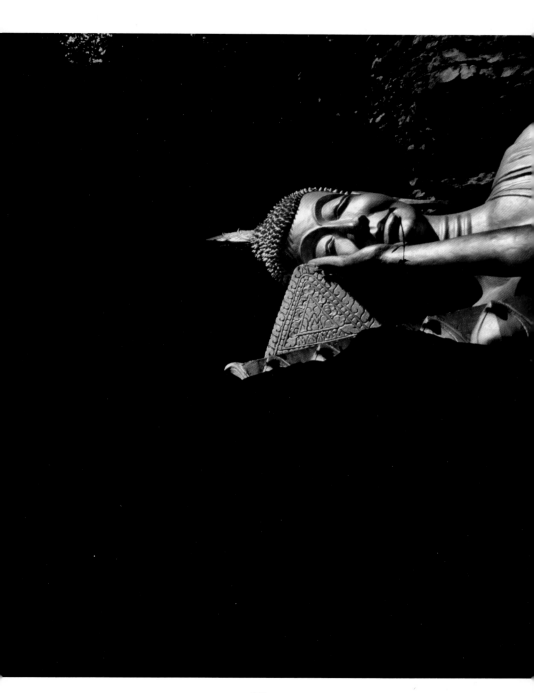

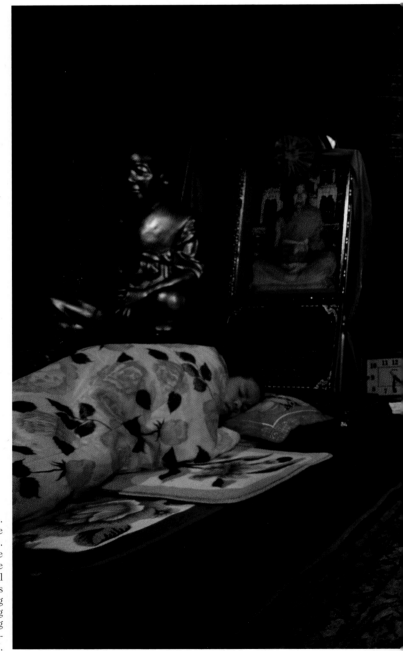

Guardians.
They sleep with the
Enlightened One.
Custodians of the
temple, these are
the novices who fall
asleep in the darkness
of Wat Xieng Thong
every night, waking
at 4.30 in the morning
to join their compan-
ions in the *kuti*.

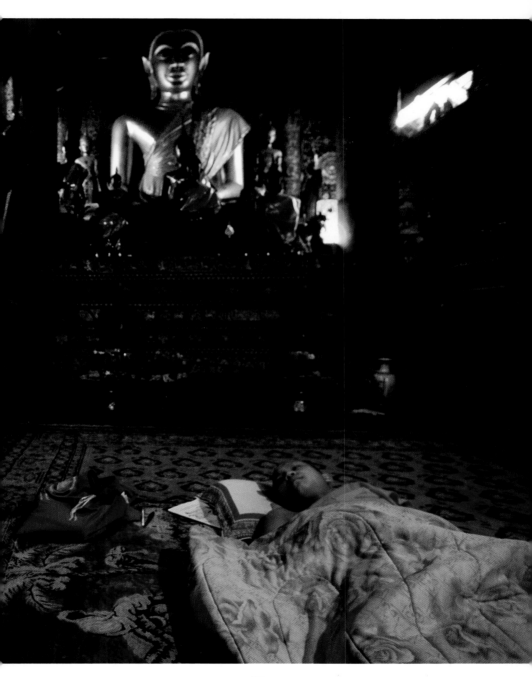

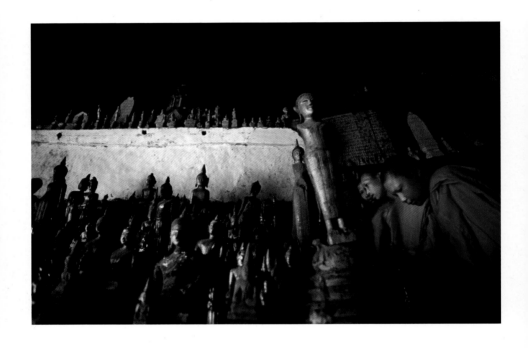

Past.
The fifteen nagas, mythical founders of Luang Prabang, live here. And it was here too that Fa Ngum, the first king of Laos, found refuge. Today the Pak Ou Caves are an immense shrine.

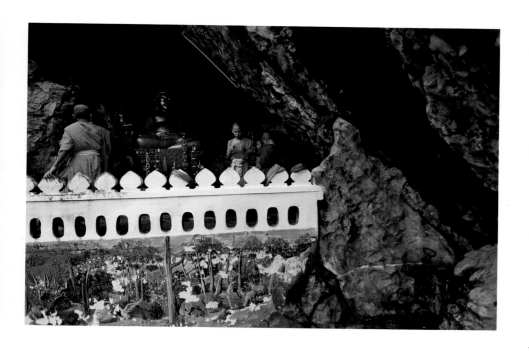

Future.
In the cave of Wat Tham Phu Si, home to hermits, a novice reads what lies in store for him on a pre-printed sheet of paper. Superstition and faith are both in the air.

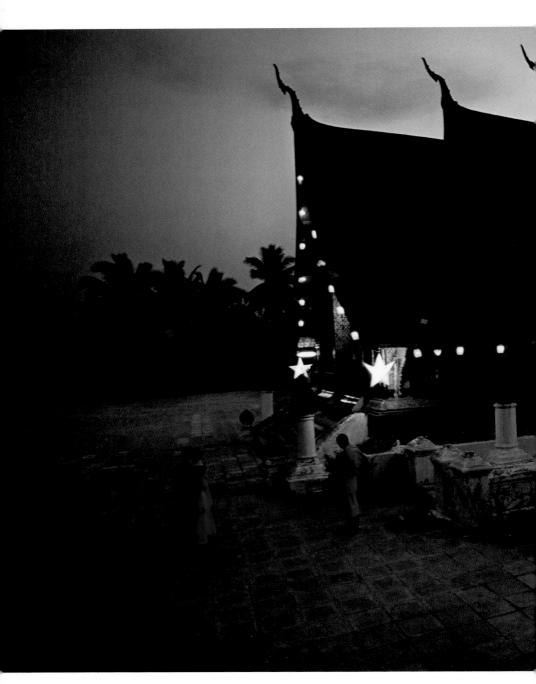

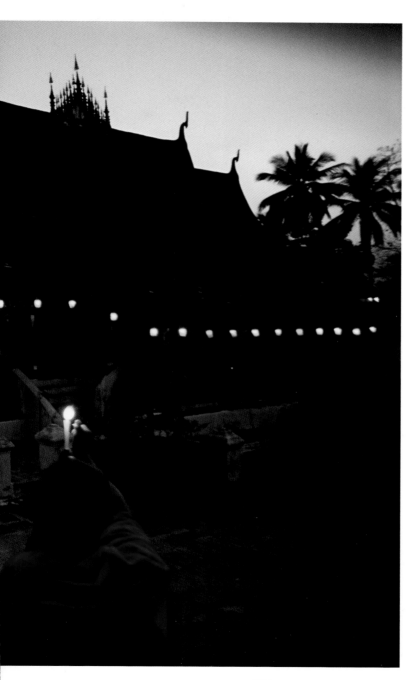

Lights.
The first have already
appeared in the sky
and the paper stars
at the entrance to
Wat Xieng Thong
will shine along with
them all night.
At dusk it looks as if
the temple is relaxing
its wings and aban-
doning itself to sleep.

103

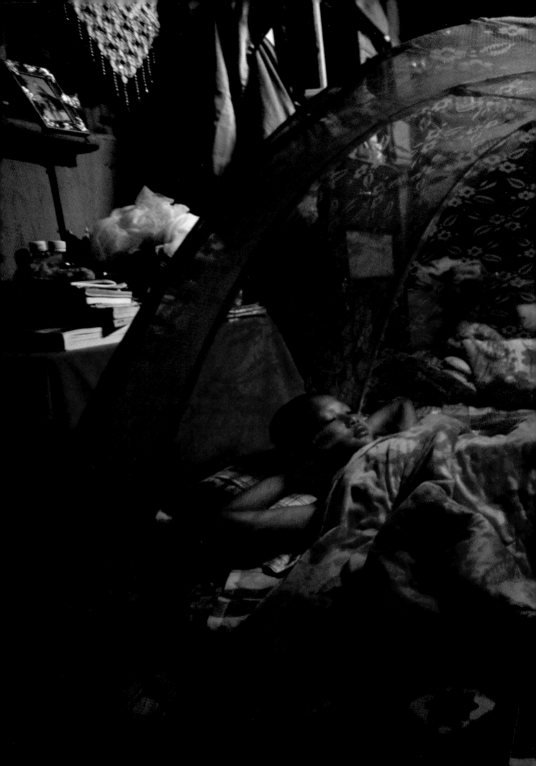

A Novice's Day

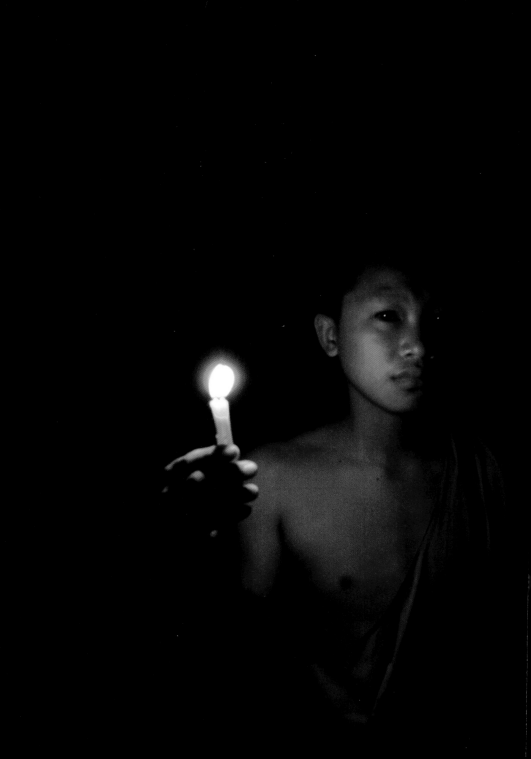

p. 104:
Lem sleeping in his *kuti* at Wat
Xieng Thong. Alongside him,
his father rests.

Previous double page:
Silence.
It is still dark when the nov-
ices get up and start their day
around five in the morning.
Keeping them company, the
croaking of frogs, the singing of
birds and the first words, spo-
ken in a whisper.

It was Tulin who told him, at the moment he was mercilessly awoken by the fluorescent light. Such important announcements ought to be made by candlelight, leaving enough darkness to absorb the emotions. "This evening, Lem, you'll be sleeping in the temple, you're going to be the guardian." This evening Lem will collect his mattress, his cushion and a blanket and lay them out on the floor of Wat Xieng Thong to watch in his sleep over the Enlightened One, and the great statue of the Buddha will watch over him with his eyes that never close and light that never goes out. And in those nocturnal hours, marked by the clock hanging from a column, as though human time fell naturally into the eternity of the divine, Lem, resting his ear on the expanse of carpets that covers the hall, will hear again the innumerable praises sung to the Master and the sins that the monks have confessed to their brothers, each asking the other about his shortcomings and receiving forgiveness together. It will be a night of invisible voices, in the temple, in the heart, in a void that the face of the Enlightened One, his calm, his detachment, will seek to fill.

To summon up his courage, and to feel less alone, Lem will repeat the name of the Buddha, almost as if it were a magic spell in order to forget everything. That name, only that name, pronounced *ad infinitum*, like a golden leaf falling lightly from heaven and immediately followed by another and then another, in this autumn of spring.

At the first prayer of the day, in the pale light of dawn, Lem sits next to the novice Soan. They are the same age, but Soan arrived at Wat Xieng Thong a month ago. Soan knows the prayers by heart, Lem still has to read them. "Reverence to the Buddha, most worthy of respect, reverence to the Dhamma, most worthy of respect, reverence to the Sangha, most worthy of respect", repeat the monks. And the voice of the chorus leader intones: "Let us unite in praise of the Most High Buddha." And the brothers again: "Let us honour the perfect, the holy, the supreme Lord, he who has attained enlightenment alone, reaching the peak of understanding. He has attained happiness, he knows the world, he is the supreme guide of every law, master of the gods and of men. He has

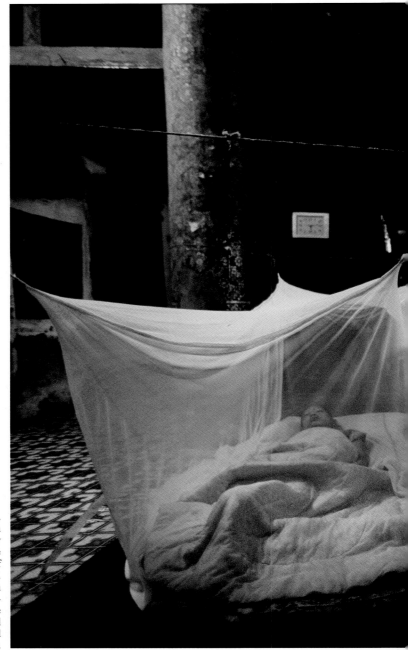

Neon.
Guardian novices in groups of three. They are the first to wake in the darkness of Wat Si Boun Houang. The flick of a switch and the eternal illumination of the Buddha is brightened by electric light in all its modernity.

110

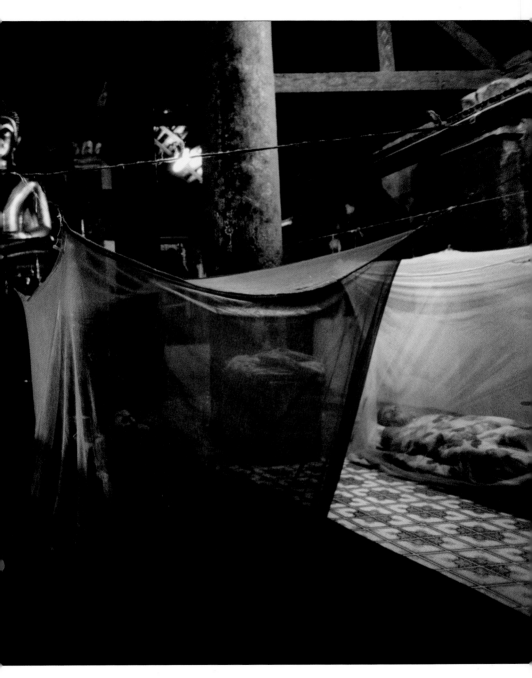

proclaimed the Dhamma, which is glorious in the beginning, in the middle and in the end." And worshipping the Blessed One, in the bow that turns the temple into a wave of the sea, the chorus concludes: "The Buddha is entirely pure, filled with compassion, boundless as the ocean; he has a vision of sublime wisdom; he has overcome the sin and the impurity of the world." One last genuflexion and the liturgy is finished, their heels touch the ground again, they go back to the *kuti*.

His begging bowl is hanging on the wall. Lem slings it over his bare right shoulder and goes down to the courtyard. Amidst the shuffle of bare feet the *tak bat* begins. Lines of monks emerge from each temple, and the hierarchy demands that the procession should start with Wat Sene, the Temple of the Patriarch, then Wat Nong, Wat Sop, Wat Si Muang Khoun, Wat Si Boun Houang, Wat Khili, and finally Wat Pak Khane. The faithful are already in the street, the women kneeling, the men standing. Lem is one of the last and still doesn't know how to open his bowl with the light grace of those who raise its lid without making any noise and, keeping in step, shut and open it again to accept more food. Behind him, Soan closes the procession. Returning to the temple, the two children leave a lump of rice on the altar of the spirits and after breakfast sweep the courtyard and the lanes around the temple. A few months earlier, they'd have been playing football together. "Soan, can you bear to stay here?" asks Lem under his breath, as the two novices approach each other, gathering the dry leaves and putting them in a tin drum tied to a bamboo pole. Soan looks at his companion and his eyes display a wisdom beyond his years.

Soan comes from Nam La, a village in the north of Laos, one day's walk from the nearest road. Around it, nothing but mountains and narrow valleys in which the farmers struggle to carve out terraces for their rice. Every morning Soan used to get up at five to go and fetch water: twenty minutes to descend to the river and twenty to climb back up. In the meantime his mother put the rice on to cook and fed the animals, the hens, ducks and pigs. Then he had breakfast with his father and younger brothers and sisters and by that time it was seven o'clock. An hour's walk to get to school and then at midday Soan set off home again. After that he would take his bow and head for the forest to hunt squirrels, birds and rabbits, or gather herbs and bamboo shoots, or go fishing. His

mother liked shrimps cooked in banana leaves. At sunset his parents came home, after spending two or three hours crossing the valleys, and once supper was over Soan would study, by himself, as the rest of his family was illiterate. "Lem, do you know what I want to do when I get out of here? Become a teacher and go back to my village school."

"There is no greater act of love than teaching. It means giving the most precious thing you have to others", the monk Boun had explained to Lem the one evening they had spent together. The Buddha had put off his entry into Nirvana for forty years to teach the Dhamma and indicate the way of salvation. This is what the Master had said: "Brothers, set out for the good of the many, for the happiness of the many, out of compassion for the world, for the welfare, the benefit and the happiness of gods and humans. Do not go alone, but two by two. Preach the truth that is good in its beginning, good in its development, good in its consummation. Make the higher life known in all its fullness and purity. There are beings that are confused, but not blinded; if they do not hear the preaching of the Doctrine they are lost."

Lem does not want to go out alone from Wat Xieng Thong and its wood, which stretches down to the riverbank. But the school, where he will be admitted in a few days, is nearby and he knows how to get that far. Walking along the street that runs through the city, Lem sees a strange figure on the opposite pavement, a very scrawny man with bare feet, wrapped in a simple sarong. Everyone in Luang Prabang knows him, and no one is afraid of him, except strangers. Lem stops and watches the old man go up to a woman silently. With the grace of a flower falling onto water the man touches her shoulder. The woman gives a start, turns round and screams, and with the same delicacy as before the beggar twists his hand, which becomes a wooden bowl, and asks for alms.

At lunch Lem tells Tulin what he has seen. "He's a madman", explains his friend, adding that there are as many legends about that man as there are costumes that he wears in different seasons: simple rags, a monk's robe, a military jacket. And with each change of clothing, that peculiar being seems to explore a different corner of his hazy mind and remembers having been a soldier with the Vietcong, then a mathematician who had studied in Russia, where his nerves had snapped forever. And finally, the snows of that distant land melted, the images grow

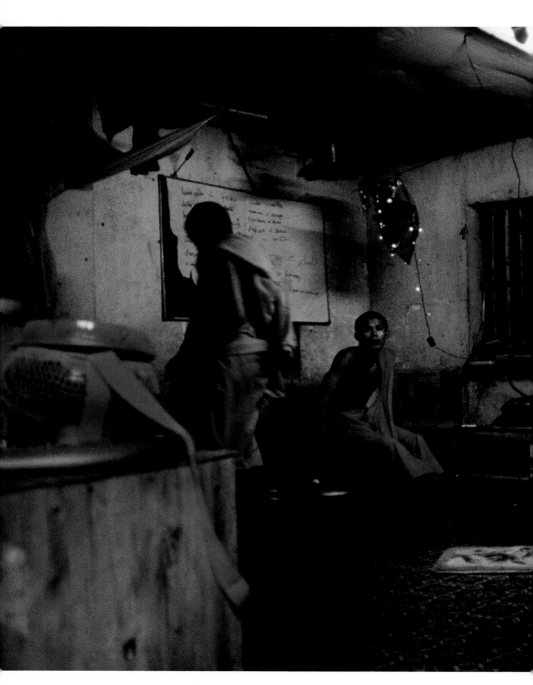

Movement.
In a *kuti* at Wat Xieng Thong the novices prepare for the first ritual of the day, dressing. A few minutes to get washed and rinse the begging bowl. Then, without making a sound, the community gathers in the temple.

gentle again, and the old man recalls his youth, as a novice. Perhaps in that moment of peace the tangle of his existence unravels. "That man went crazy", intervenes the monk Hon, head of Lem's *kuti*, "because no formula, no theorem could explain to him the pain and the cruelty, the sufferings he has undergone and the ones he has inflicted in revenge. But if you want to know more about him, Lem, come with me to Wat Phou Kouay, Buffalo Hill Temple. The Venerable Chandharinh will be able to tell you a story and explain it to you."

The tuk-tuk begins to climb into the forest and two very long nagas of stone descend the steps to greet visitors. But the tuk-tuk stops higher up, on the square, next to a beige Mercedes from which protrudes the body of a monk, lying under the engine. He was a mechanic before taking vows.

The Venerable Chandharinh is giving audience: a married couple want their son to become a monk, and they would like him to live in this temple, far away from the city, from shops, girls, money and computers. It is possible, but they will have to wait a few months, for a place to become free. The parents bow three times, thank him and withdraw. The Venerable motions the monk Hon to enter and Lem follows him. He takes a packet of documents out of a box and Hon puts them in his bag of purple satin. Phra Chandharinh offers a glass of water to his guests, but Lem waits for his superior to drink before doing the same. Hon speaks of the morning's encounter and, smiling, tells of his novice's bewilderment. The Venerable rests his chin on his breast and takes a deep breath. He speaks in a solemn tone: "I was the same age as the monk Hon when I entered the monastery, twenty-six. Before setting out on my journey, my name was Punjam and I was a primary-school teacher in a village on the Ho Chi Minh trail, one of those villages on which American planes dropped thousands of bombs during the Vietnam War because they had to return to their bases in Thailand with empty bays. Novice Lem, did you know that Laos is the most bombed country in the history of humanity, more than Europe during the Second World War? Look in the garden of Wat Si Boun Houang. There are two flower vases at the foot of the *kuti*: they are bombs. And despite these atrocities we carried on. I studied and I found a job. I was a man like any other, full of worries: money, food, a roof over my head. I was unhappy.

So I entered the monastery, the first time for three months, and then I chose to stay there forever. I came to Luang Prabang in 1982. I spent a long time meditating in the forest and in the end I arrived here, in this monastery, closed since 1975, and started to restore it, and in 2001 I had it rebuilt. When the communists took over Laos, they wanted us to believe only in Lenin and Marx, but Buddhism cannot be forgotten. The Buddha who has given us his knowledge: this is the only weapon that can be used to combat violence."

Descending from the hill where meat was once butchered for the royal family, the tuk-tuk returned to the asphalt road, skimming perilously close to bicycles, mopeds and pairs of novices returning to their *kuti* at dusk. The monk Hon and Lem stop in front of the old primary school, with its corrugated-iron roof and its classrooms opening onto the huge courtyard, where every morning dozens of children in their uniform, a white shirt and red scarf, do gymnastics before lessons and where in the evening huge wedding feasts are sometimes organized.

At the entrance of Wat Xieng Thong, Lem meets Tulin. He is holding a sheet of paper in his hand with the words of a song by the most famous rock band in Laos, the Cells, like the brain cells of the mad mathematician, like the combat units that the Venerable Chandharinh saw marching through the jungle at night, like the rooms of a prison or a monastery, two institutions that many novices still find it hard to distinguish. Tulin has to send the lyrics to a friend from one of the internet cafés in the centre and is in a hurry. "Lem, you remember that this evening you're on guard?" Lem nods. In his *kuti* Ngock has already folded his mattress and mosquito net, as if Lem were about to leave and go home. As if his retreat from the world were over and that night were to be his last gift to the Buddha.

Before the evening service, at seven, a family gathers at Wat Xieng Thong, for a private celebration of thanksgiving. To the Lord who has given them understanding and compassion, the faithful respond by offering themselves, totally, and every part of their body is a dedication to the Master: "We offer our feet and ten fingers; may they be the golden candlestick before the Buddha. We offer our hands and ten fingers; may they be a lotus flower for the Divine Sage. We offer our thirty-two teeth;

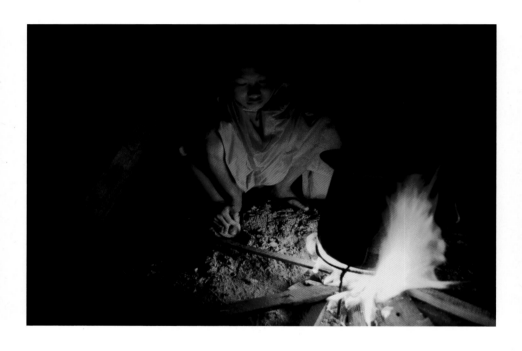

Simplicity.
In spite of everything, it's cold. Among the palm trees of Wat Sene, at dawn on a February day,
a novice lights a fire and heats water to wash himself.

Greatness.
The first prayer of the day at Wat Sop. In unison, monks and novices sing the praises of the
Enlightened One: "The Buddha is pure, full of mercy, boundless as the ocean."

LEM – Initiation of a Little Buddha

may they be the same number of buds for the Divine Sage. We offer our ears; may they be leaves laid down in the presence of the Divine Muni. We offer the nine million and eight hundred thousand hairs of our head; may they be an offering to the Divine Sage. We offer our bust; may it be the pole to support the golden flag laid at the foot of Phra Muni. And we offer the heads of us all; may they be platters of gold laid at the feet of the Divine Sage."

If he had wished to Lem could have added to that list of spiritual parts of the anatomy his own, much greater offering. After locking the twelve doors of the temple and pulling the windows half-shut, Lem will lie down with his head towards the Buddha and offer him his body, abandoned in sleep, defenceless and innocent. No one imagined that this such intimate union, to which only two beings that sleep together can aspire, would happen so soon.

And better than a hundred years
lived without seeing the sun rise and set,
is one day lived seeing the sun rise and set.
(Dhammapada, 113)

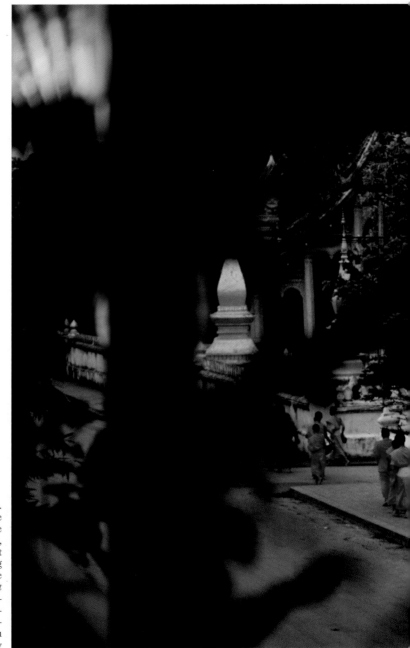

Peace.
The last star of the
night shines on the
veranda of Ban Khili,
one of the finest
residences in Luang
Prabang. It is the
hour of the *tak bat*
and guiding the nov-
ices is the magnifi-
cent Wat Sene, im-
mersed in its golden
tranquillity

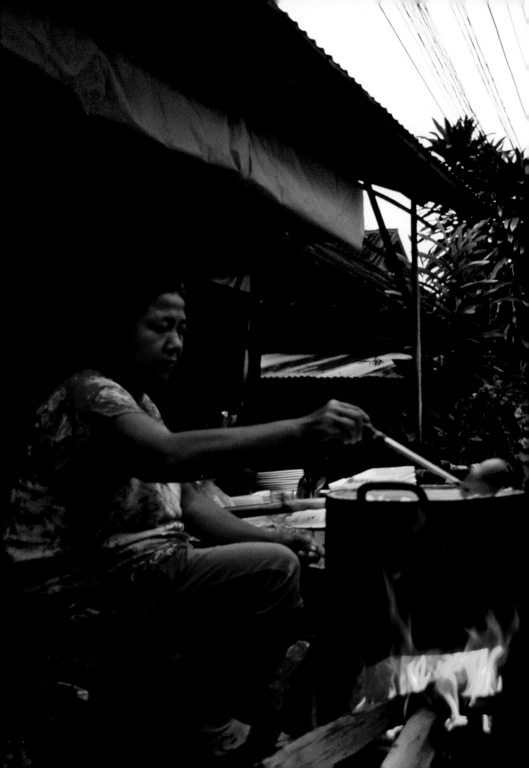

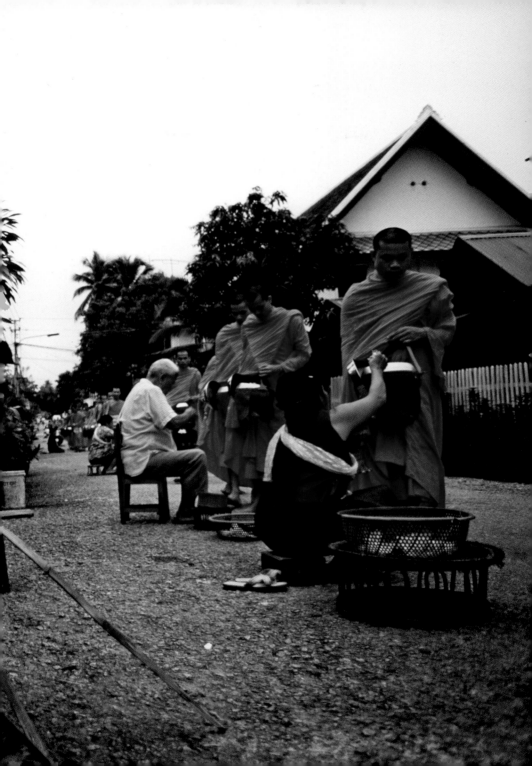

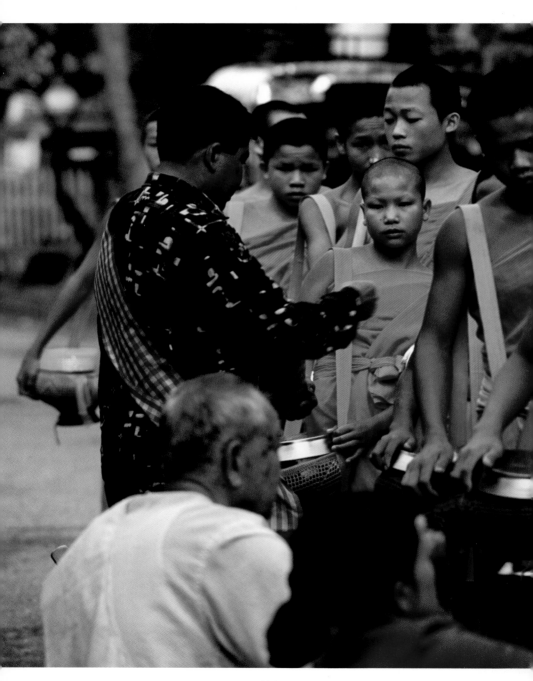

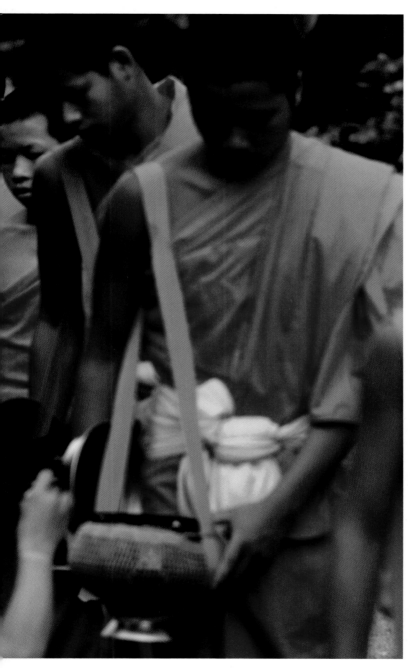

Previous double page:
Hierarchy.
Leading the *tak bat*
procession are the
monks, wrapped in a
robe that covers the
whole body. Novices
leave one shoulder
bare. But the faithful
make no distinction
and offer the entire
Sangha its food for
the day.

Alliance.
Lem is now part of
the Sangha and this
is his first *tak bat* in
Luang Prabang. He
too is covered by the
pact that has united
the secular and the
religious for centu-
ries: in exchange for
food for the body, the
monks offer prayers
to nourish the soul.

Summons.
To the majestic sound of the drum, interrupted by light touches of the cymbals,
the community of Wat Ho Sieng gathers for prayer.

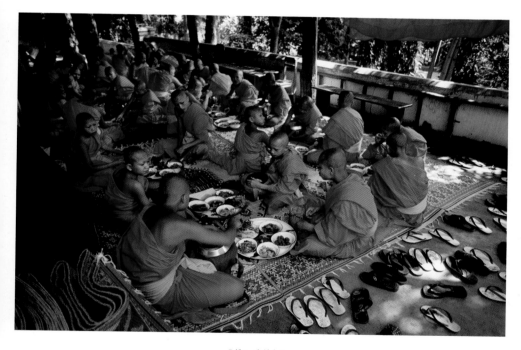
Like children.
On the veranda at Wat Pak Kane, the novices come together for the first of the day's two meals. Dishes prepared by the local women are added to the offering of the *tak bat*.

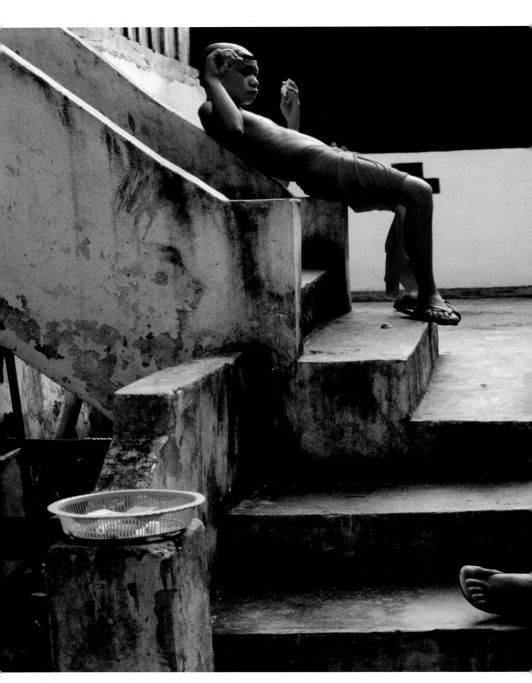

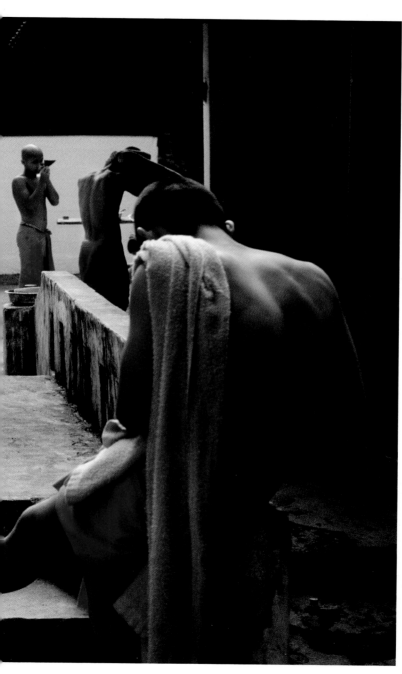

Full moon.
Each month, when the moon is at its brightest, monks and novices renew their vows of humility and shave off their hair and eyebrows. But to do the job the novices of Wat Aham have to make do with a piece of broken mirror.

131

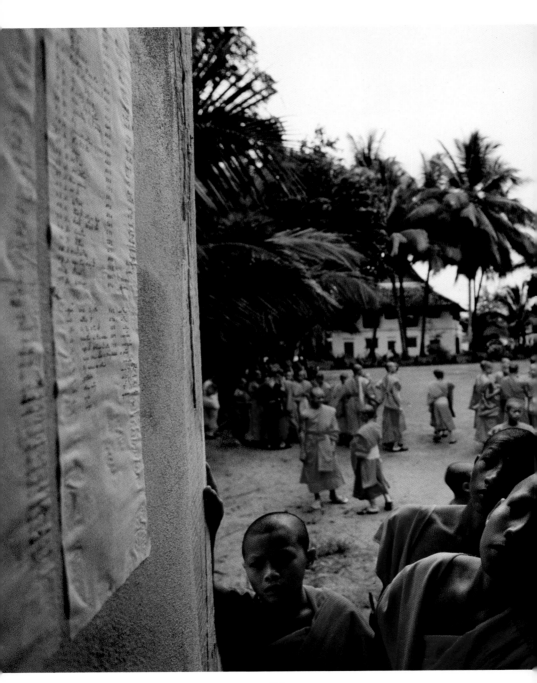

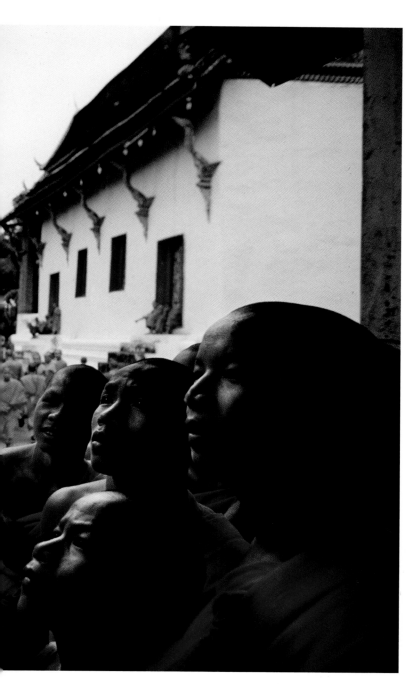

Plans.
It's the first day of school after the summer break, and the novices of Luang Prabang assemble in the school at Wat Pa Khe. The class lists have just been posted and they are all curious to find out who their new companions will be.

133

On the way home.
A group of novices
returns to the temple
after taking part
in the ceremony of
blessing a bridge. To
protect them from
the sudden shower of
rain, nothing but a
sheet of plastic and a
woman's parasol.

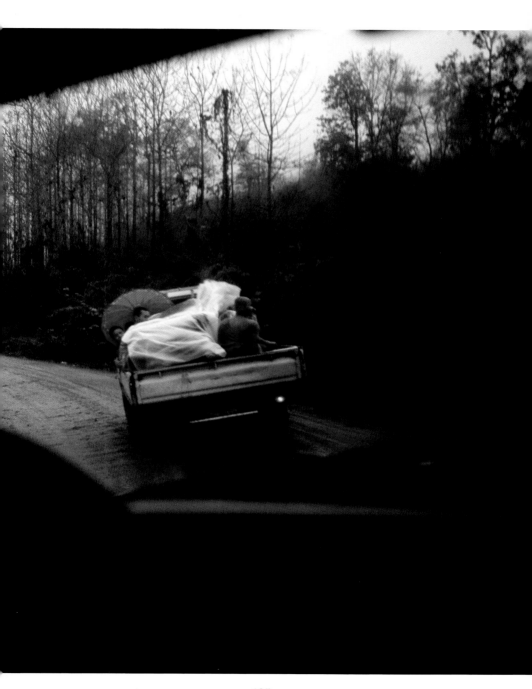

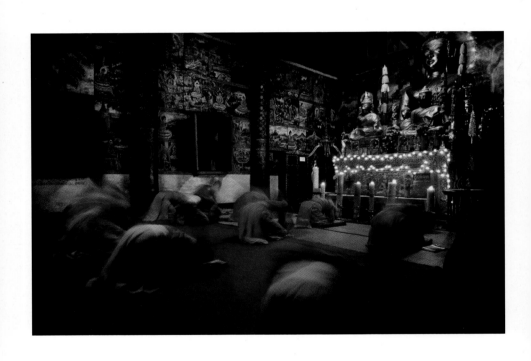

Waves.
At dusk every temple in Luang Prabang turns into a sea of orange.
The Sangha gathers for the last prayer, beneath the painted walls of Wat Phan Luang.

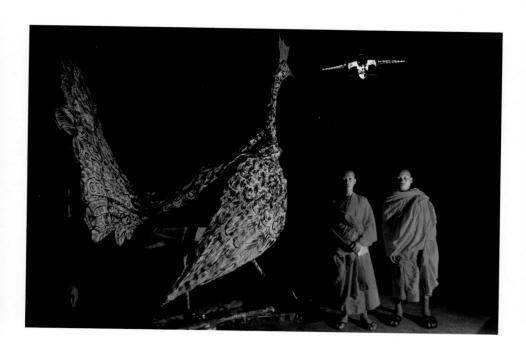

In flight.
Time to celebrate the Boun Ok Phansa. Paper boats, fantastic creatures and even the model of an airplane appear in the temples. Fantasy takes you far.

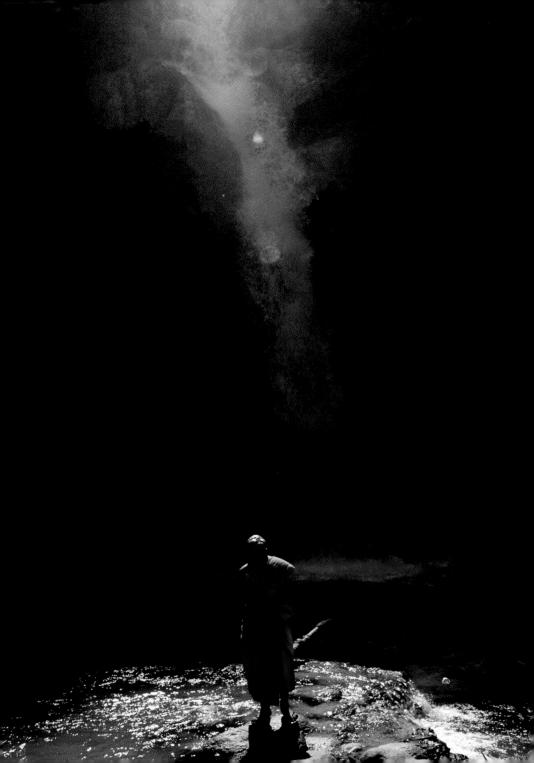

Water

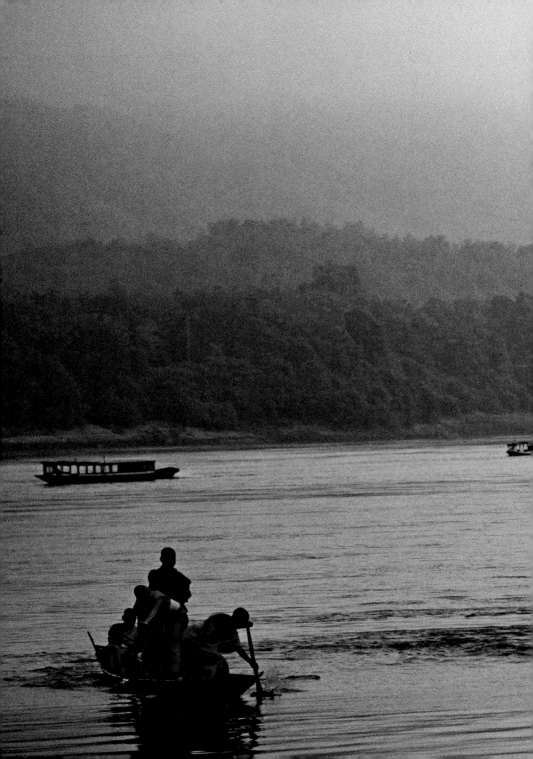

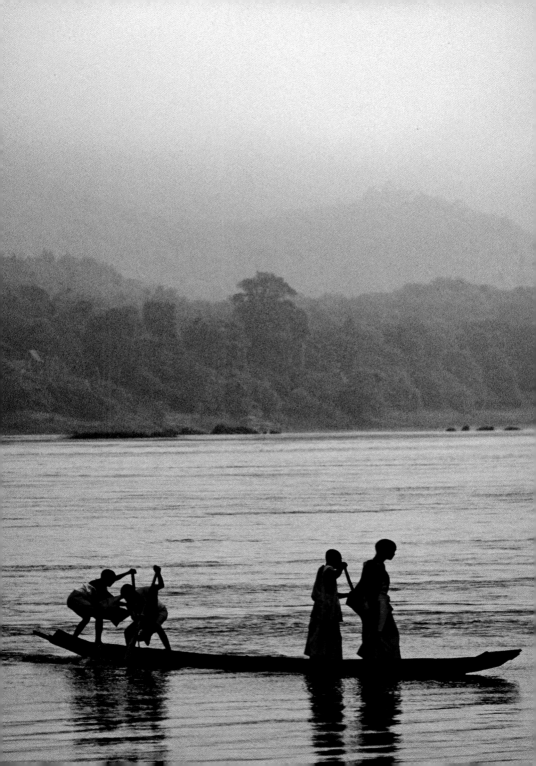

p. 138:
Lem admiring Kuang Si Falls.

Previous double page:
Mother of all waters.
This the name of the Mekong,
the river that runs through life
in Luang Prabang. Novices liv-
ing in the monasteries on the
opposite bank cross it every
morning to go to school.

"Do you know what my mother used to say to me when I went swimming in the river? If the Ngeauk get you they'll eat you." And at that point, seeing her grandson huddling under the blankets, as if clinging to a boulder protruding from the swift current of the night, Lem's grandmother told him the story of a girl who had fallen into the Mekong from a boat and how her father, mad with grief, had found her after a day's walk downstream, lying on a rock. Her body was covered with cuts and her face was white, as if every drop of blood had been drained from the veins. "The fault of the Ngeauk", whispered his grandmother, "the serpent gods, the dragons of the water." Lem did not want to hear any more. He closed his eyes and held his breath, feigning death, as if to deceive those monstrous creatures: there was no point in them approaching his bed and sinking their jaws into his dreams, as he was no longer there, he had gone somewhere else. But his grandmother, who lived on the warm blood of those legends and the aura of magic that sprang from her voice, went on talking: "There were four Ngeauk, three females, the white queen, the black queen and the queen with flowing tresses, and one male, Ai Tong Kuang, the serpent king of the great river. If you go to Luang Prabang one day Lem, you'll climb Mount Phou Si and look down at the rivers, the Mekong on one side and the Nam Khan on the other, and among the reflections you may see a strange light. It'll be them, they'll still be there, the serpent gods."

Lem's grandmother liked to plunge into the caverns of time, going back to her remote past, when she used to listen to her mother's stories as a little girl. But Lem, who has by now spent his fifth day in the monastery and has already seen two more novices arrive, ignores her advice and crosses the Mekong with his cousin Ngock, walking up the steps that lead to Wat Chom Pet, the Diamond Monastery, and its beautiful terrace.

Lem has never climbed so high since he arrived in Luang Prabang and for the first time he is able to see the shape of his new world. It is here that he will live, between these rivers and these shores, one day after another, always the same; here, on this peninsula from which the golden mist of the sunset is visible in the distance, and whose various neighbourhoods

Proportions.
Nature is so grand
and man so small.
Uniting the sky, the
river, the houses, the
trees and every living
being is the golden
ray of the stupa of
Wat Aphay, the mon-
astery "without sin
and without danger."

pp. 148-149:
Meeting.
A sacred place in the
city's history. Here
the Nam Khan flows
into the Mekong.
And here the novices
of Wat Long Khun
land every morning.
Another adjustment
of the robe, and then
off to school, carrying
a precious possession:
the oar of the dugout.

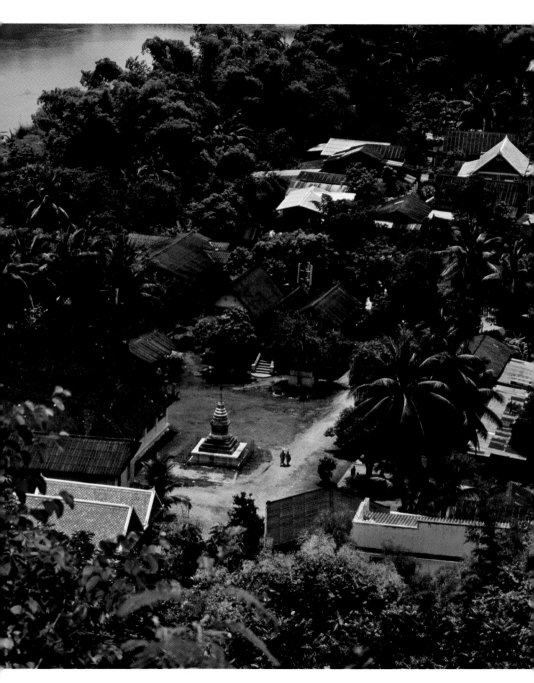

can be made out, linked by a network of tiny streets that connect one house to another, one temple to another, even one era to another: the Laotian one, built of wood, and the French one, hard, imperious, built of stone. And in Lem's memories, his dreams, his desires, the sap begins to flow again, as in the veins of a beautiful leaf that the wind has torn from a tree and a kind hand has picked up and placed in a glass of water. For an instant, forgetting the sun that is setting behind him, weighed down by the immense shadow of the mountain, Lem loses himself in that wonderful panorama and feels that in a not so distant future he will be part of it too. And at every moment, to comfort and confuse him, to frighten him and nourish him, there will be one element in particular, the most sacred, the most dangerous, the one that brings life and death: water.

This morning Lem got up at four, almost forgetting that he had slept inside Wat Xieng Thong. He gathered his things, opened the door again and went back to his cell. After the round of begging, he helped his companions to put up a canopy and a little channel in the shape of a serpent under the porch of the temple. And while setting up that little altar, Lem noticed a woman seated in silence next to the pagoda that houses the king's enormous hearse. As soon as the monks moved away, the woman walked crossed the courtyard, with difficulty, carrying a bucket of water and shifting it from one hand to the other. Reaching the temple, she took a tiny golden Buddha out of her bag, put it under the canopy, and then climbed on a stool to pour water into the channel. Praying, she watched the gentle trickle of water flow over the shoulders and robe of her statue of the Enlightened One. The water, passing through the body of a serpent, heir of the Ngeuak, and washing the body of the Buddha, had become holy. The woman collected a little and put it in the bucket. When she gets home she will sprinkle it in every corner to protect her house, and will wash the face and hands of her grandson, newly born but already exposed to the dangers of the world. Before leaving, the old lady kneeled one last time at the foot of Wat Xieng Thong, and when she had finished praying gently poured a cup of the blessed liquid onto the ground, so that those fresh and scented drops would enter the realm of Thorani, Mother Earth, and transmit to the deceased the merits that all the faithful obtain through their good deeds. Even the dead want to quench their thirst and feel the dew of life falling on their ghosts.
In a few days Lem, along with the Phra Bang, the monks and the other

novices, living images of the Buddha, will take part in the New Year's Day procession and the people of the city will pour water on their arms, their hands and their robes, the older ones offering it in a silver cup, the children shooting it at them with plastic water pistols. Each in his or her own way will invoke the arrival of the rains and the end of the hot weather.

In the last hours of the afternoon, from the viewpoint of Wat Chom Pet, Lem watches the Mekong flow past at the height of the dry season, between rocks and pale islands on which the inhabitants have constructed innumerable stupas out of sand, some covered with rice flour and decorated with paper flags bearing the effigy of the Master and the signs of the Zodiac. Every grain of sand is a sin, a sad memory, a suffering that the spate of the river will carry away, as soon as it starts to rain. It will not take long for the current to grow turbulent again and the Mekong, which was once called Nam Nyai Ngu Luang, the Great River of the Giant Serpent, will begin to foam among the rocks, before spreading out like a lake further south, at Si Phan Don. Observing the Mekong, inexhaustible source of prosperity and divine wisdom, Lem understands why the Enlightened One, through the voice of the monk Boun, had spoken these words: "Suppose, monks, a man is carried along a river by a current which looks delightful and charming. Then a sharp-sighted man standing on the bank sees him and calls out, 'My friend! Though you are being carried along in the river by a current which seems delightful and charming, yet further down there is a pool with waves and whirlpools, with monsters and demons. My friend, when you get there you will come by your death or mortal pain!' Then, o monks, hearing the other's call, that man struggles against the stream with hands and feet, for the current is synonymous with craving. The pool and the waves are anger and agitation, the whirlpools cupidity, the monsters and demons desire for a woman; and going against the stream, o monks, refers to renunciation of the world, and struggling with hands and feet means to put forth energy. The sharp-sighted man standing on the bank is the Tathagata, the Rightly-awakened One."

Travelling upriver from Saigon, Francis Garnier, leader of the first French expedition on the Mekong, had reached Luang Prabang on 29 April 1867. Lem recalled the lesson given by his teacher Xoi, at the village school, in which he spoke of that man and his dream of turning

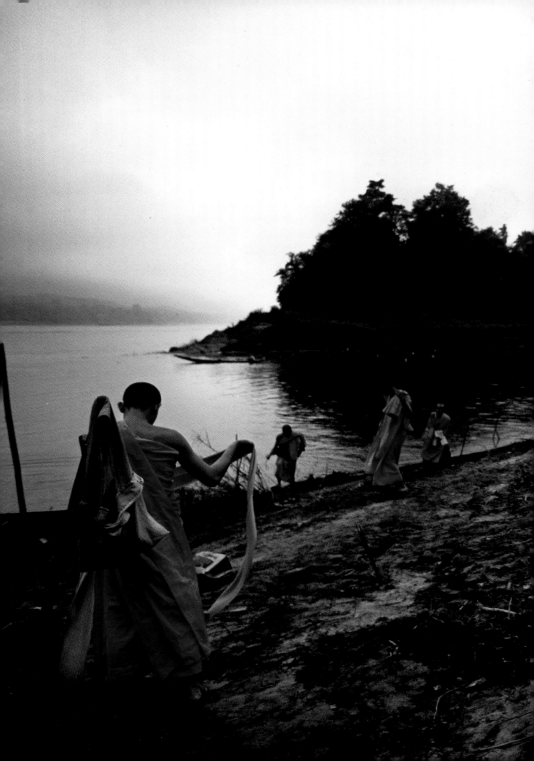

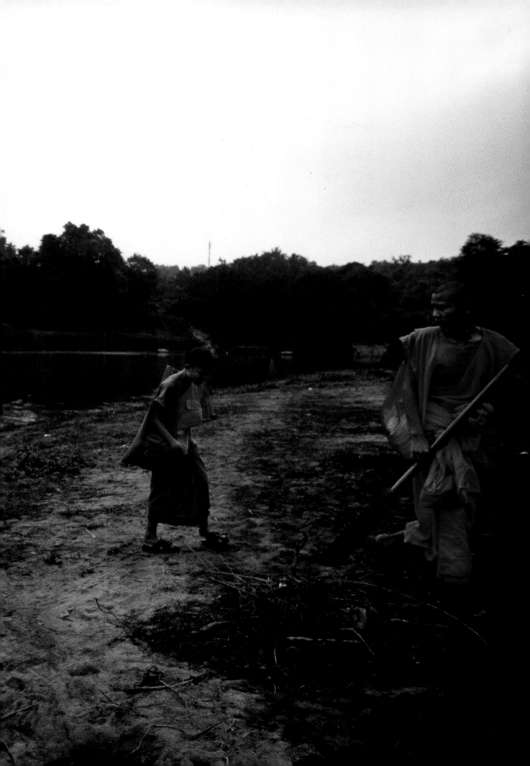

the Mekong, the "mother of waters", into the most extraordinary trade route from China to Vietnam. But the scheme had foundered on the rapids that block the current between Laos and Cambodia. Lem liked his teacher, with his tortoiseshell glasses and red and blue pens tucked into the pocket of his shirt as if they were the stripes of a military officer. And he had liked it too when he described the gruelling exertions of that expedition, which after ten months of exhausting effort had reached Luang Prabang and stopped there to rest. Teacher Xoi had shown his pupils the drawings made by Louis Delaporte, the artist who had accompanied the expedition, and one of them, the most beautiful, had been made from the terrace on which Lem and his cousin have taken refuge in search of relief from the heat. Apart from the television mast, nothing has changed since then: not the forests of tamarinds that run along the banks, not the boats moored in the river, not the glittering summit of Phu Si.

Continuing his lesson, the teacher had told them about the time in 1887 when Auguste Pavie had arrived on those same banks: an explorer and diplomat, he was the man who twenty years later would turn Laos into a French colony. Laos, in French, is simply the plural of Lao. If Lem had been able to eavesdrop on the gossip that went on in the Parisian salons of the early 20th century he would have discovered that his homeland, so difficult and remote, was fated to attract the most eccentric and undisciplined of Europeans, unlike Hanoi and Phnom Penh, which were seen as destinations for the ambitious and enterprising.

In the last century the region was a magnet for those who were seeking adventure, who were dreaming of wealth and a new start in life. One day Tulin, who speaks English well and studies it even at night, asked a foreigner what young Americans, "not the rich, but the ones like us", do if they want to change their lives. The man had told him they go to fight in Iraq.

Tulin does not know whether those young men, whose music he listens to and whose sunglasses he envies, seek the comfort of a divine word before they go to the front. But he knows that the king and dignitaries of Luang Prabang, as they prepared to go into battle, would pray before the altar of Wat Phone Xai, the temple of the Buddha of Victories. Even today, in peacetime, the faithful come here to ask for help in the daily struggle against the enemies of the soul. Tulin and Lem are well

aware of it: the cause of evil, but at the same time the defence against its terrible attacks, are the *phi*, the spirits. "There are good spirits, that watch over the rice paddies, the temples, the houses", Lem's mother had explained to her son on the day when the hut in which they kept their tools had mysteriously burnt down, "but there are evil spirits too, the Phi Phetou, the souls of those who have died a violent death, who cannot be reborn and so torment the living. And then there are the Phi Pob, demons that make their way into the heart and poison it; and watch out too for the Phi Phong, once human beings, experts in magic, but with no scruples, whose anger makes them spit fire in the face of wayfarers and turn them in turn into cruel spirits. Lastly there are the Phi Lok, who take delight in frightening us. But be careful, Lem, because the *phi* hide everywhere, in the air we breathe, in the earth, among the roots of trees, in caves, in abandoned temples, but above all in the water, even in a single drop." The same drop that the Buddha's words turn into a luminous symbol of renunciation: "Like a drop of water runs off a lotus leaf, so the wise man does not cling to anything he sees, hears or thinks."

As evening begins to fall, while the sky is still streaked with pink, Lem and his cousin go down to the river and get back in the boat. But instead of heading for Wat Xieng Thong, they ask the boatman to go upstream as far as the mooring place of Wat Phone Xai. Tulin is waiting in the temple yard, along with a friend who came out of the monastery a month ago after five years of cloistered life. The young man still has short hair, but is unrecognizable: he's wearing a pair of tight black trousers, a white shirt, sunglasses. Another kind of self-assurance, but with no elegance. He and his uncle have got hold of a tuk-tuk, which he has now brought for blessing, to get his new job off to the right start. It's Tuesday, the most propitious, because the *phi* are stronger and defeating them today means keeping them at bay for longer.

At the entrance to the temple, on which appear scenes of hellish torture intended as a warning to sinners, three women are standing. One of them is pregnant and asks the monks, one young, the other in his nineties, to pray so that the spirits do not enter her and do not touch her baby. Nothing is purer than the placenta, nothing more fertile than amniotic fluid for those who seek to be reborn, even in adversity. The mother-to-be gives the Venerable monk a pail of water in which she has placed a few slices of ginger, some lotus leaves and a fruit, *mak som poi*,

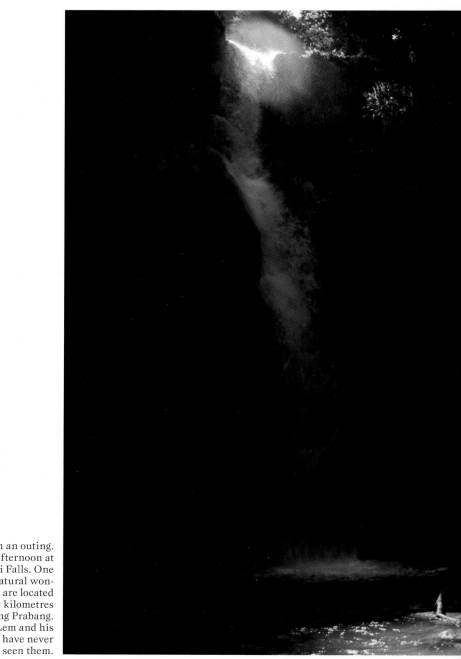

On an outing. A spring afternoon at Kuang Si Falls. One of Laos' natural wonders, they are located just a few kilometres from Luang Prabang. But Lem and his cellmates have never seen them.

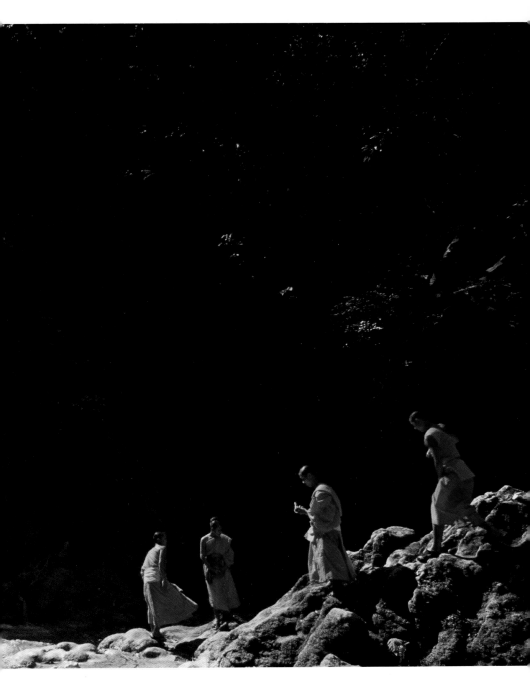

gathered in the forest. Then she offers him three slender, soft candles, one as long as her right arm, from the middle finger to the elbow, one for her left arm, and a third the same length as the circumference of her head. If she wished, she could have added a fourth, long enough to run round the oval of her face. The monk weaves the candles together, attaching them delicately to the edge of the pail, lights them and prays, his words mixing with the drops of wax. At the end of the invocation, the monk immerses the three flames and the light dissolves in the water, blessing it. At home, after dipping her hands in that holy liquid, the woman will pass them over her belly; and that gesture, in a country where peace holds sway between Animism and Buddhism, will be both the last barrier to evil and the Buddha's first caress of her child. With his hands raised and palms turned outwards, the Phra Bang will invite her too, the mother, to lay down her weapons and calm the frenzy of egoism. To her too the Master will offer the raft of awareness to pass through inclement weather, telling her not to fear the water that flows in rivers, in nightmares peopled by monsters and inside her body, where a new being flickers in the darkness. And at that sound imperceptible to the human ear, but loud in other worlds, the Ngeauk and the wretched servants of evil withdraw into the gloom of their caverns.

Returning to Wat Xieng Thong aboard the tuk-tuk, now immune to any possible accident, Lem, Nu and Tulin watch the procession of faithful carrying statues of the Buddha to the temple. By now the canopy is full. It holds a crowd of Enlightened Ones, each with his gaze turned in a different direction, as if to dominate the entire space. Nu and Tulin stay to chat a while longer, but Lem goes back to his *kuti*. He is hungry and cannot eat. And so he fills his stomach with the only substance permitted him, water. One glass after another, with no blessing, with no prayers, but just with the inconsolable fear of not making it to the next day.

Inconceivable, monks, is the beginning of this samsara.
A first point is not known of beings roaming and
wandering the round of rebirth,
hindered by ignorance and fettered by craving.
Which do you think, monks, is more:
the stream of tears that you have shed as you roamed
and wandered on through this long course,
weeping and wailing because of being united with the
disagreeable and separated from the agreeable
– this or the water in the four great oceans?
(Samyuttanikāya, II 179)

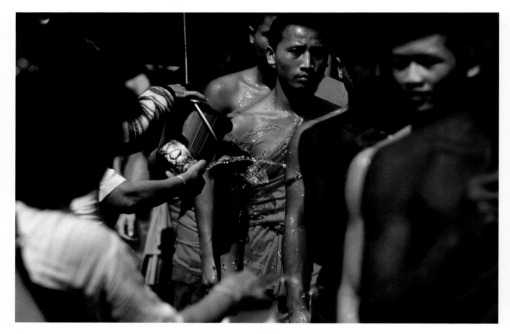

Caresses.
During the New Year Festival, Pi Mai, monks and novices parade through the city.
The faithful greet them as living Buddhas, pouring water onto their bodies and clothes.

Rain.
Water is low in the Mekong,
the air is incandescent.
In April, people and nature
wait for the first drops to fall
from the sky.

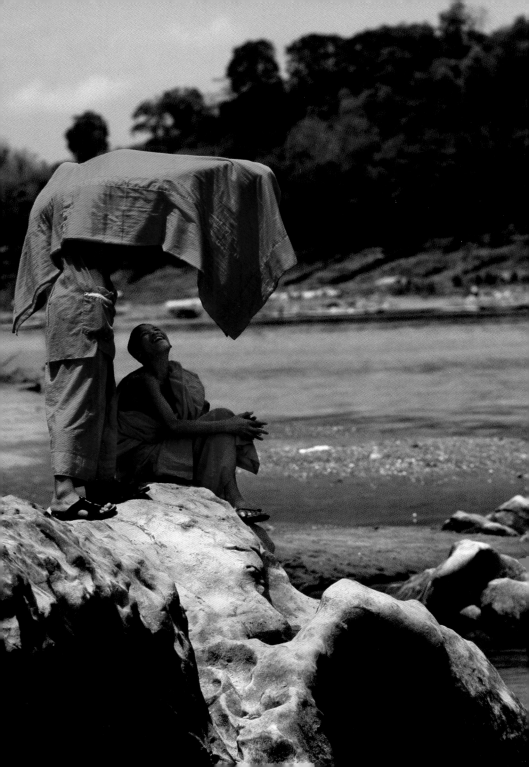

Ships without sea. At the end of the rainy season and the Buddhist Lent the Boun Ok Phansa is celebrated. At night the faithful entrust flowers and candles to the river. But the paper and bamboo boats built by the novices are left in front of the monasteries.

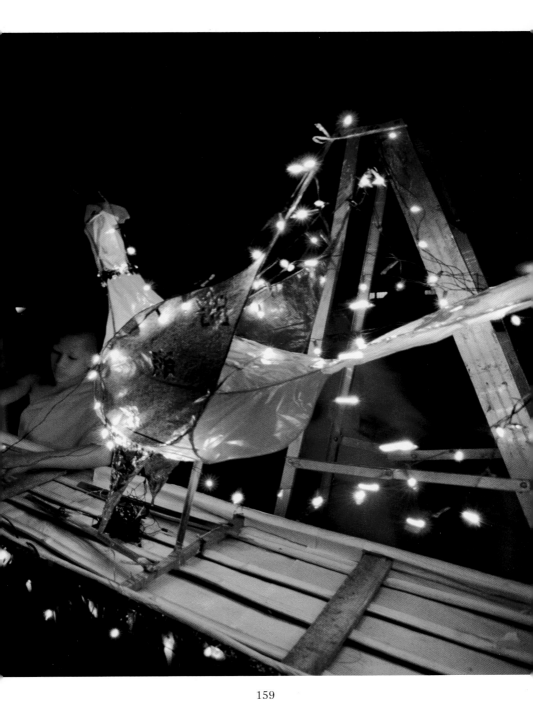

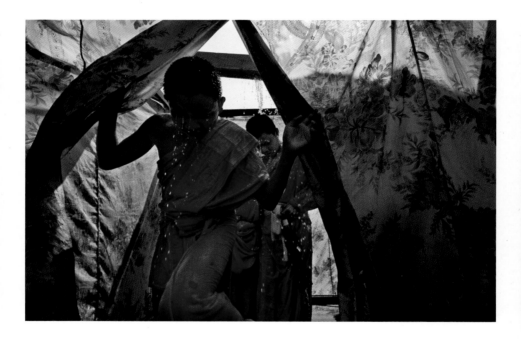

Purity.
At the end of the Pi Mai festival, monks and novices enter a sacred enclosure and the
water that pours from a channel in the shape of a serpent refreshes and blesses them.

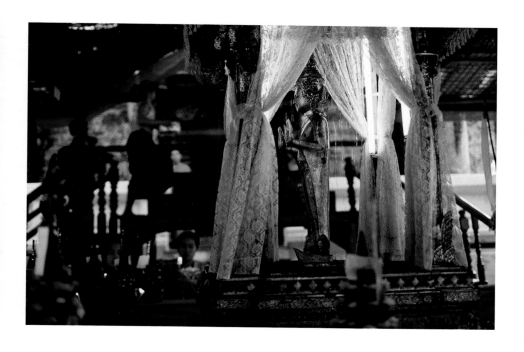

Prosperity.
At New Year the statue of the Buddha called the Phra Bang, protector of the city, receives the devotion of the faithful. The water that runs over its body is sacred and protects against evil.

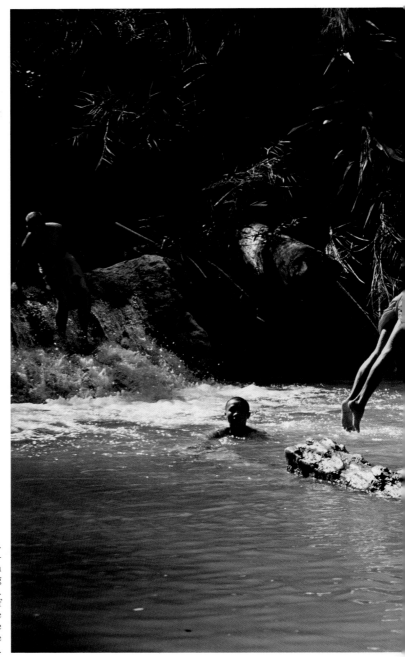

Energy. Lem and his companions enjoy a dip in the splendid setting of the Tat Sae Falls. Maybe it's a breach of the ten rules. Maybe it's the irrepressible call of adolescence and its rights.

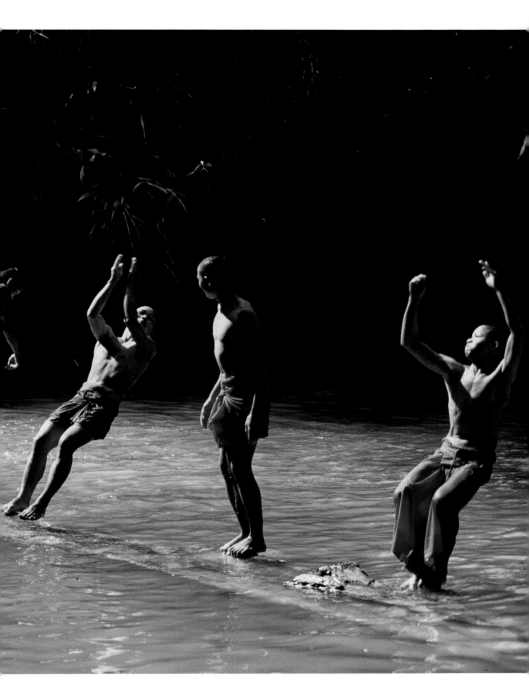

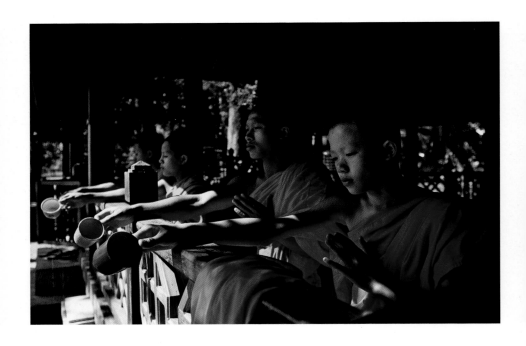

Thirst.
To convey merit to the dead, the novices of Wat Khok Pap pour a trickle of water onto the ground.
In this way the prayers and the good actions of the living can slake the thirst of the departed.

The deities of the river.
In August the boat race called the Bun Sung Hua is held. To pay tribute to the tutelary genies of the waters, the monasteries take on each other in a thrilling contest.

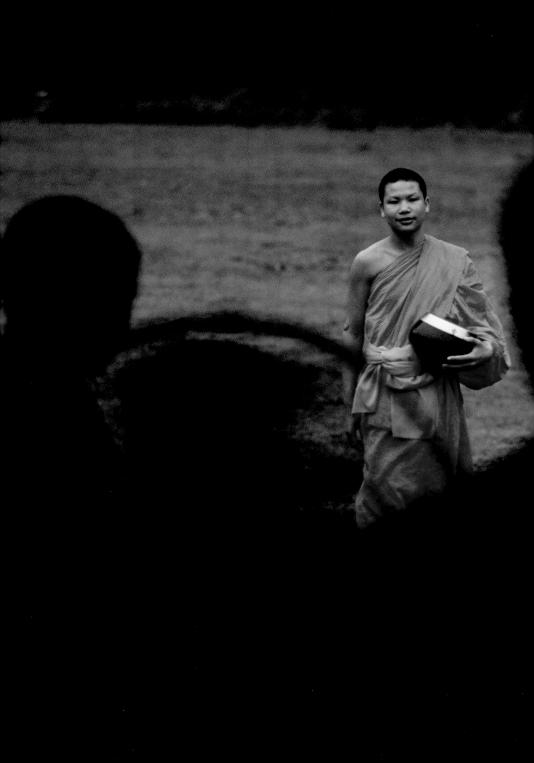

The Community

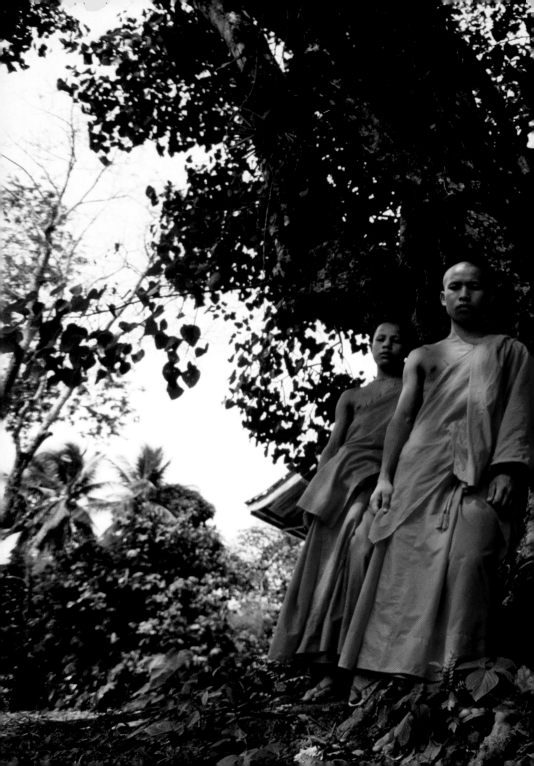

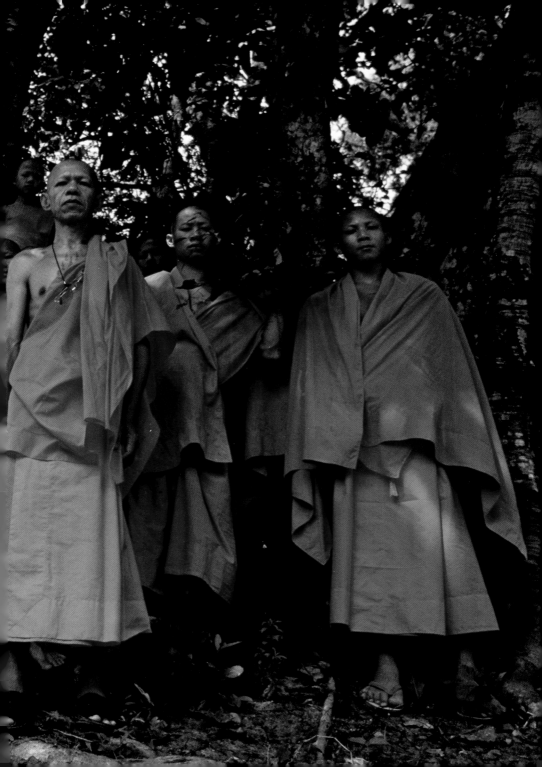

p. 166:
Lem sets off to join his compan-
ions in the temple.

Previous double page:
Like a tree.
Strong, protective, resistant
to the inclemency of life. An
image of Satu Sai, head of the
community of Wat Khok Pap,
on the bank opposite Luang
Prabang. Far from the city and
its temptations, monks and
novices seek the purity of their
origins.

He felt it move in the early hours of the night, rising and breaking like a wave against the walls of his stomach, and his efforts to sleep had proved vain. Then all of a sudden the storm had abated and the water that Lem had drunk so avidly before going to bed had become a calm lake, and had transmitted its modest nourishment to his body. His muscles had relaxed and his eyes, behind their closed lids, had contemplated the spectacle of a kindly darkness free of nightmares. But around three in the morning, while the silence of the moon is still watching over the monastery and its inhabitants, Lem feels the hollow open up again, as if a cavern had formed in his belly and his arms, legs, shoulders and head were nothing but strange inflorescences, sprouting among the rocks of that desolate cavity. The little novice get up, leans his back against the wall and, now wide awake, decides to wait for dawn, envying the sleep of his companions and recalling the words they had exchanged the evening before. Each had confided his desires for the future and the images were so vivid that they remained hanging in the warm air of the cell, and as soon as the monks had fallen asleep their dreams had lain down next to them, like a transparent covering that the warm breath of hope would keep alive until such time as real life would give it substance and weight.

Lem's brother, who at the end of the rainy season would be going home after six years spent at Wat Xieng Thong, wanted to become a computer programmer. His cousin Ngock, a tourist guide. Tulin had already made up his mind: first a waiter and then manager of an internet café. Lem wanted to study medicine. In the cell opposite, Kampè pictured himself in a bank counting money, "and it doesn't matter if it's not mine, I love that rustle between my fingers." Finally there was Aruyo, twenty-six years old, the only one who wanted to stay in the monastery forever. The younger novices were afraid of him. To Lem, who like them all had cried the first night in the temple, Aruyo had suggested without a smile that he dry his tears quickly and put his trust in Dhamma, "because with the Dhamma you look inside yourself and feel you are riding on the clouds. The Dhamma feeds you and by praying every day you will feed your family."

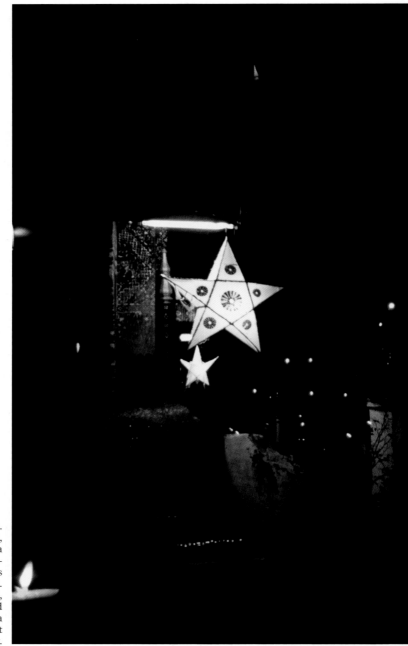

Disciples. On a full moon night, the Makha Bousa festival commemorates the miraculous birth of the Sangha. Without any warning, 1,250 monks gathered in front of the Buddha and formed the first community.

Lem had lowered his eyes, ashamed of his weakness and of the anger that he felt towards his superior, and had waited a long time before raising his head and finding with a sigh of relief that he was alone again.

Four days have gone by since that sudden, violent burning sensation, as if the wound that Lem had inflicted on his arm as a child, with a bill-hook, had opened again. But on this cruel and endless night, when even the clouds obscure the comforting beauty of the stars, Lem thinks again of Aruyo's advice and prays, spelling out in his mind the words that he reads on the photocopies illuminated by a torch; and the prayers, like the water, offer him a little comfort, filling the empty spaces between thoughts and calming his distress. Without realizing it Lem falls asleep again and when he wakes his hand is lying on the white sheets of the breviary.

The first noises rise from the courtyard in front. Every day, while it is still dark outside, Madame Phone prepares breakfast for the monks who live at the temple. Lem follows her movements from a distance, and recognizes the sound of the spoon stirring the frying mix, the knife chopping vegetables on the wooden board, the water hissing as it cools the boiling oil, and from the large black pot rises a column of steam, carrying up to the sky the aroma of a delicious dish made of fish, aubergine, garlic, chilli, parsley and onion.

Every morning for ten years Madame Phone has been honouring the pact of alliance that unites the community of the faithful and that of the monks, the Sangha. Two parts of a single fruit that grow and ripen together. In the 1950s, during the civil war, the seventeen-year-old Madame Phone had been a nurse. One day she had recognized one of the richest men in Luang Prabang among the wounded. He was in a coma and in that long sleep had dreamed of wanting to eat and drink, but someone near him had told him that as he had not given anything when he was alive, he would receive nothing when dead. Upon waking up, after a week of darkness, the man had confided that nightmare to the young woman who had snatched him from the jaws of death, telling her, in the intimacy that had developed between the two of them, that he wanted to change his life. And when peace returned he was often to be seen at the temple making offerings of food and money. But the dream and its message had also touched that elegant girl dressed in white. She too had understood that generosity lights our path through this world.

The care of the wounded had been followed by that of her family and now that her own children had grown up Madame Phone took care of the children of others, those novices from the mountains and the rice paddies who helped her to pick vegetables, to cook, to never feel alone.

Lem likes to follow Madame Phone around her kitchen garden, which is located at the tip of the peninsula, at the confluence of the rivers. Together they weed the ground, tie the shoots to supports and water the plants, and soon they will be sowing lettuce and planting tomatoes and courgettes. To Lem it feels like being in the village with his grandmother and reminds him of when his mother, coming back from work in the evening, used to line up the spades and hoes against the wall of the shed. In the shadows cast by a light bulb hanging from a cord, the tools looked like horrible creatures with their heads bowed, waiting to turn round at the sound of a step. When he was small Lem had kept away from that mysterious corner of his courtyard and was afraid when his father asked him to come with him to shut the spades up in the shed. The spirits were there lying in wait for him, without a doubt, but thinking back on it now, wrapped in the robe that protects him from evil and imposes on him the duty of understanding, Lem feels affection for the child that he had been and, gazing at the Mekong, he sees the other, distant shore as if it were another, more adult age toward which he is slowly making his way.

On the other bank, protected by the forest that conceals them under a heavenly vault of branches and leaves, stand some of the finest temples in Luang Prabang. There live the monks who have chosen to enter the monastery not in order to come back into the world when they are more mature, but to distance themselves from all modernity and to "become enlightened like the lotus flower that opens its petals on the appearance of the sun." Monks forever, austere, solitary, steeped in the Dhamma and in a rhythm of life that supports absorption and meditation. On that bank of the Mekong there are no roads, just paths that let wayfarers pass only to close behind them with a rustle of leaves. It is said that this impenetrable shore is the favourite abode of evil spirits, and to keep them at bay a statue of the Buddha has been set on the top of a rise, invisible when the vegetation is at its thickest. But now that the great leaves of the teak trees have fallen to the ground and look like a sea ruffled by the wind, its waves frozen by magic, Lem is able to see the gleam of the Enlightened One shining through the bare branches. Yet no one is will-

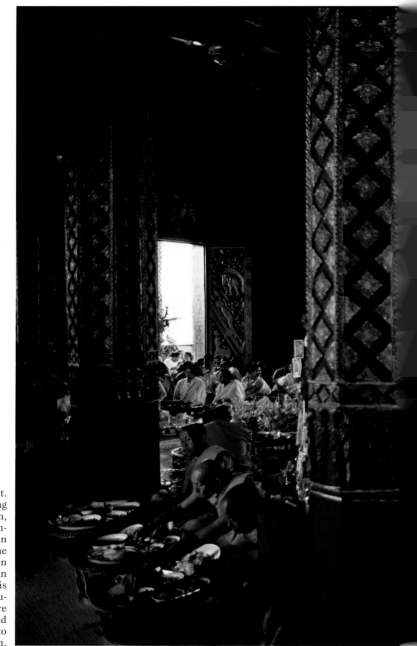

Great Heart. This is the meaning of Wat Manorom, one of the most important temples in Luang Prabang. The entry of an old man and a young man into the monastery is celebrated in its beautiful hall. The entire community, lay and religious, gathers to welcome them.

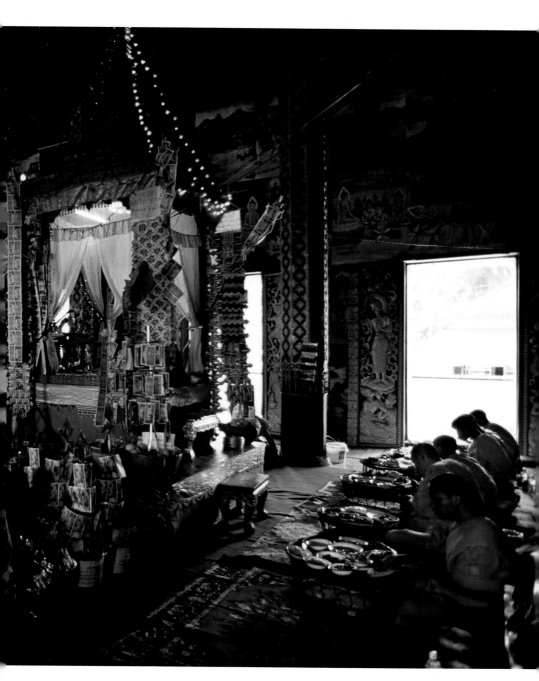

ing to climb to the summit and the story is told of a stranger, heedless of the warnings of the locals, who had ventured into this jungle, tempting fate. He had never come back. Perhaps a snake, or perhaps a way of disappearing and starting all over again elsewhere.

Before disappearing in the undergrowth and turning into a narrow and dangerous trail, the path through the mountains splits in two and forms a wider branch, as if to warn that there is still time to make the right choice, and not just for a stroll. Walking along this path, which runs safely through the forest, you arrive at Wat Khok Pap, the temple of Satu Sai.

While picking a few sprigs of parsley and watering the newly sprouted plants, Madame Phone suggests to Lem that he should meet this monk, who is not yet fifty but already a legend. "Even if you leave the monastery at the end of your studies, you will always remember him and the harmony that holds sway in his community. My son will give you a lift. You will cross the Mekong together and in the evening he will come to fetch you. Go, and then tomorrow you'll tell me all about it."

Satu Sai greets his visitors at the top of the bank that slopes steeply down to the river, and his figure, silhouetted against the sky, at once sentinel and judge, marks the boundary between two worlds. Beneath him novices clamber up and down, carrying on their backs sacks of sand and cement to finish the flight of steps that leads from the landing stage to the temple in a hurry, before the rains come. Up until ten years ago no one lived here and the monastery, which had come under attack by the Black Flags at the end of the 19th century, was abandoned. Satu Sai used to come to this bank as a child with his father, a doctor, and after gathering herbs and fruit, they would stop among the ruins to rest, to eat, to feel themselves father and son to one another. A marvellous silence reigned. Satu Sai, who was then called Sam Nuam, had never forgotten this place. Not even in Vientiane, where he had gone to study chemistry and fireproofing methods. Life went by peacefully and into the formula of happiness came the love of a girl and the idea of marriage. But slowly a sense of unease opened up a breach among the little misunderstandings of daily life. Looking inside himself, Sam Nuam had discovered that "only the Buddha is able to answer our questions, for he is the truth." And to the most extreme question, of whether he was willing to abandon his attachments, his home, his work, "like swans abandoning the pond and leaving one refuge after another", Sam Nuam one

day answered yes. At the age of twenty-five he entered the monastery, with a dream: to found his own community amidst the rubble of Wat Khok Pap. Together with his first assistants, Satu Sai embarked on a fierce struggle with the forest, felling, uprooting, clearing, burning, and asking forgiveness for that violence from each tree, until the old temple reappeared, with its courtyard, the steps leading to the garden and even the ancient ambulatory for meditation. Word spread. Satu Sai and his radiant intransigence attracted more novices, who sought in him a guide to overcome their revulsion at an ever more corrupt society.

In the shade of an open pagoda, under which the Sangha gathers to eat and pray, Satu Sai explains what he is doing to Lem. "I don't want to know anything about the past of the young men who come here. My duty is to teach them to be new, more conscious people. In the temple everyone has to find his place, because the important thing is not the individual but the community. I am like a great tree that accepts and shelters all. Buddhism has taught me to look after others, to be concerned with the pain of others. Before I didn't care about them at all." Lem observes Satu Sai's face with wonder and would like to find a wrinkle, a line of tension that would match the weight of that confession, but the Venerable remains composed in his authoritative silence and with a glance invites one of the monks to accompany the novice from Wat Xieng Thong on a short walk. Lem obeys, without asking anything, and the last thing he sees before heading for the unknown is a bird perching on a metal bowl, pecking at a small banana left there for him.

The monk and the novice walk along a path that climbs between the rocks and grows ever steeper and narrower, until without any warning in front of Lem, who is panting with the effort, appears a strange clearing, a copse of slender trees that open like the corolla of a flower around a pond in which a hut stands a few steps from the bank, isolated in the water. It is Wat Nong Sakeo, the small temple of meditation. In solitude, in the one completely bare room, lives a young monk who at the age of twenty-four left his family and his job to devote himself to the Buddha and his words. Unlike his companions, he eats just one meal a day. Every so often the inhabitants of a nearby village come to visit him and offer him food and water. This wood is a holy place, a temple that has put down roots and feeds on air, and every creature there lives in peace, without any fear. To kill here is a sacrilege, more than killing elsewhere.

Dogs.
Part of the community too. An affectionate and welcome presence, even when they lie on the novices' sandals. But any contact with women is prohibited.

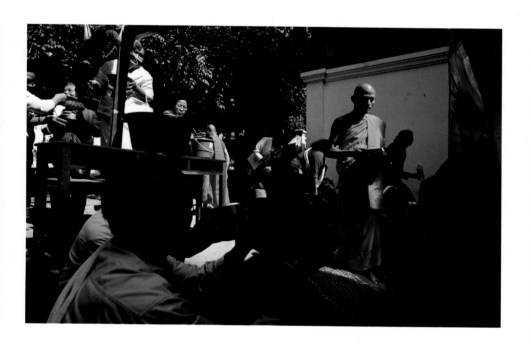

Growth.
During festivals the most deserving monks receive a special recognition. In the sacred enclosure they are blessed with water offered by the faithful.

Lem has heard voices and among the trees he sees a young mother and her daughter, bent over a carpet of orange lilies. They are praying and the little girl is holding a small bamboo perch to which are tied two tiny birds of a dazzling emerald green. "This time it is I who am setting you free, and in a future life it will be you who will set me free." After pronouncing these words, a song of praise to the continual transformations of existence and an augury for a good rebirth, the woman unties the birds and places them on a smooth stone, where Satu Sai's monks come to meditate. After a few seconds of disorientation at their unexpected freedom, the birds hop about uncertainly and then take flight.

On his return to Wat Khok Pap, Satu Sai greets Lem with a basket of freshly picked fruit. On the riverbank, fabulous in the luxuriance of its foliage, grows an ancient mango tree and its fruit is of such special quality that it was once reserved solely for the king's table. Satu Sai calls Lem aside and, opening a fruit, cuts out its large stone. "Lem, listen to the words of the monk Nagasena who over two thousand years ago explained the cycle of rebirths to King Milinda thus." Picking up a book, Satu Sai sits on the veranda of his *kuti* and begins to read: "Imagine, sire, that after eating a ripe mango, a man plants the seed and that a great mango tree grows from it and bears fruit. And the man, after eating a mango from the new tree, plants its seed from which another tree will grow and will bear fruit. In the same way what is born here dies here, what dies here rises elsewhere. This, sire, is *samsara*, the cycle of rebirths." Closing the book, Satu Sai says: "This, Lem, is the painful destiny that awaits each of us and like every disciple of the Buddha I too seek to put an end to the continual cycle of suffering. And to do this I struggle with myself, to improve myself every day."

Looking at the river, Lem sees the boat approaching and takes leave of his master for a day, and perhaps for a life, with a deep bow. On the way back, Madame Phone's son asks the novice about his day and Lem tells him, happy but unsettled too. When they say goodbye, the man asks one last question: "Do you know what Wat Khok Pap means?" Lem shakes his head, frightened by the weight of another difficult truth. "It means the temple where one is conscious of sorrow. Goodnight Lem." And let it be truly a night of peace, for this child who tomorrow will witness for the first time the farewell to life.

Not by birth is one an outcast;
not by birth is one a brahman.
By deed one becomes an outcast,
by deed one becomes a brahman.
(Suttanipāta, 142)

Without a break.
At Wat Pak Khane,
during the Phra Vet
Festival, for seven-
teen hours, the most
able monks and
novices read out in
turn the stories of the
Buddha's previous
lives. These are the
famous Vessantara
Jataka.

185

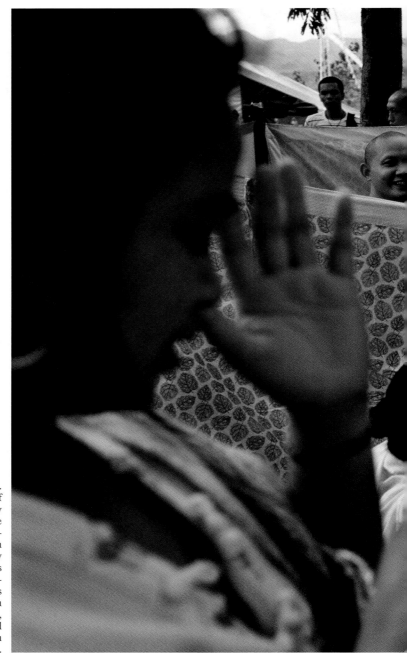

Generations.
In the village of
Pu Mo, the "Misty
Mountain", the
entry of a twenty-
six-year-old man
into the monastery
is celebrated. He is
a carpenter. To hon-
our the death of his
grandfather and wish
him a happy rebirth,
the young man will
spend a whole year in
the temple.

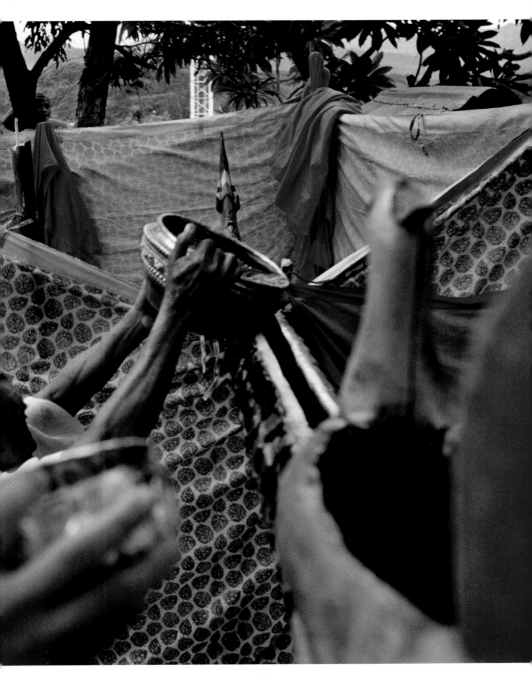

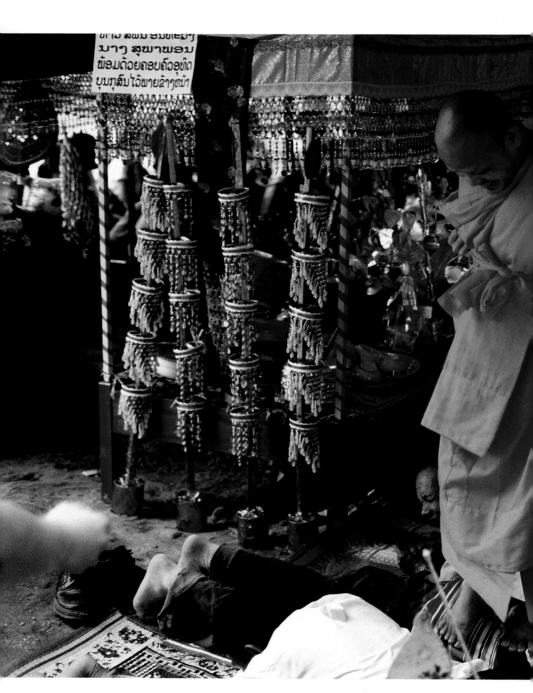

Contact.
The monk's body is a
vehicle of salvation.
And to avert all evil,
men lie on the ground
and let the Sangha
walk over the backs.
The sole concession
to women: walking
on their scarves.

189

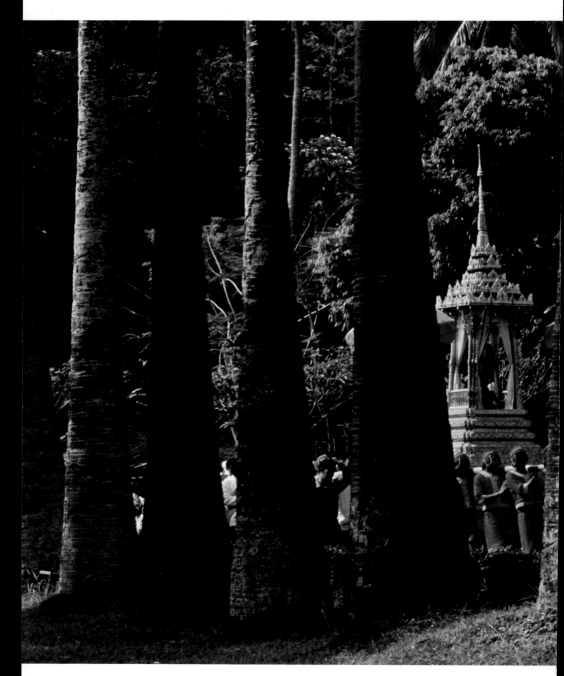

In the king's house.
At the end of the Phi
Mai, the statue of the
Phra Bang is carried
back to the museum,
once the home of the
royal family. Another
year will have to pass
before the symbol of
the city can salute its
subjects again.

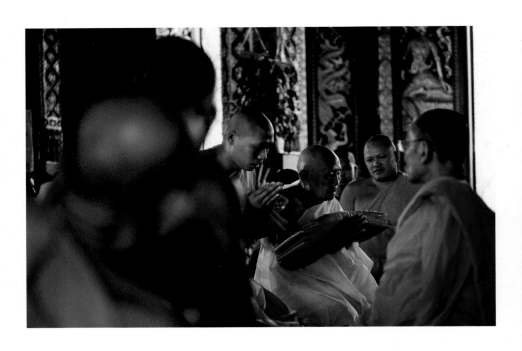

Closure.
Before taking his vows, he has divided his land up among his children.
Somsy, a 78-year-old widower, has chosen to leave his worries behind. His only desire,
to prepare for the life to come.

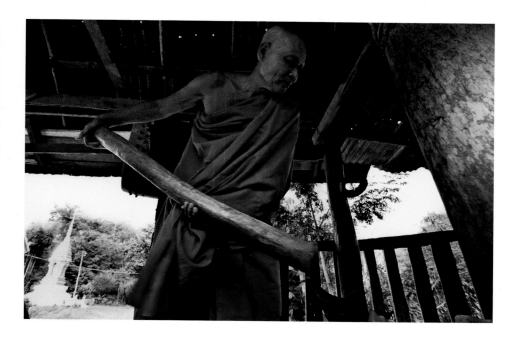

Opening.
Every day, sixty-year-old Satu Peuy rings the bell and calls the faithful to prayer.
Until a few months earlier he had been running a hotel. Then the choice to change his
life and found his own community.

Refuge.
A tent inside a cell,
in a wood on top of a
hill. This is the loca-
tion of Satu Peuy's
tiny Sangha, a few
kilometres from
Luang Prabang.

194

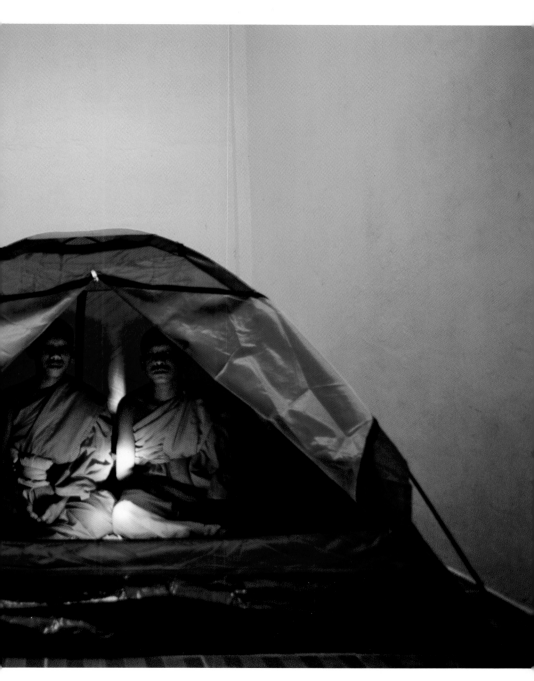

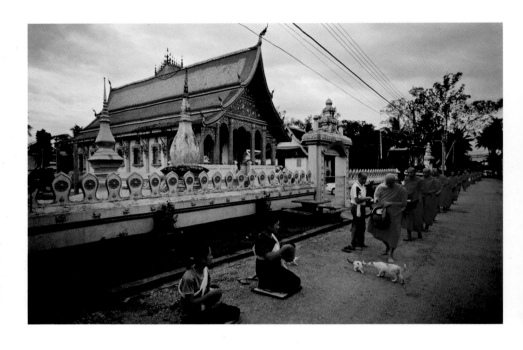

State of grace.
The long procession of the *tak bat* stops for a few seconds.
Tenderness must be respected. Leading the Sangha is the extraordinary figure of Phra
Khamchan Virachitta, abbot of Wat Sene since 1949 and part of Luang Prabang's his-
tory. A few days after this picture was taken, the abbot passed away at the age of 87.
A rumble of thunder from a clear sky announced his departure.

Veneration.
It is the festival of Vixakha Bouxa, a celebration of the birth, the enlightenment and the death of the Buddha, events that tradition holds to have taken place on the same day of the same month. Receiving the homage of the faithful in front of his temple, Wat Sene, is the image of Phra Khamchan Virachitta. It was his favourite portrait: leaving for meditation in the forest.

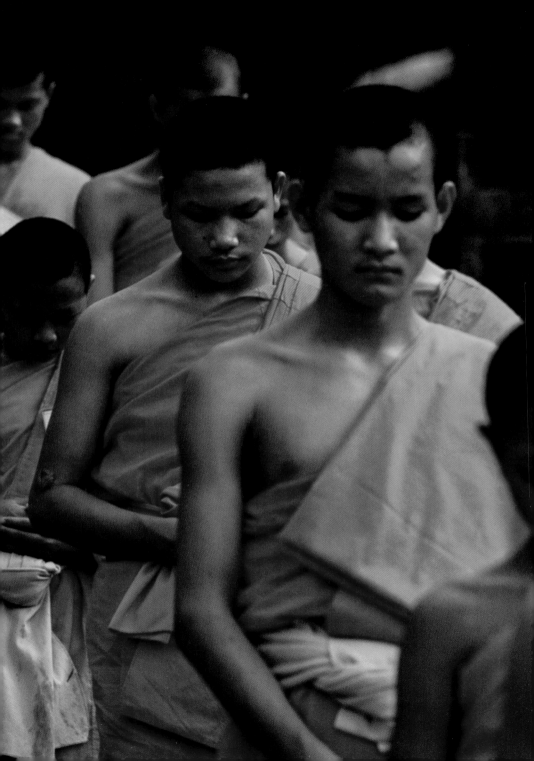

Rebirth

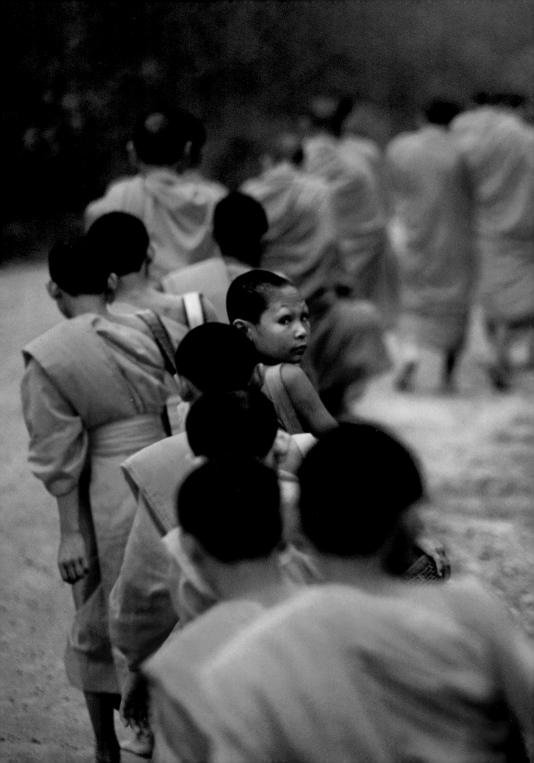

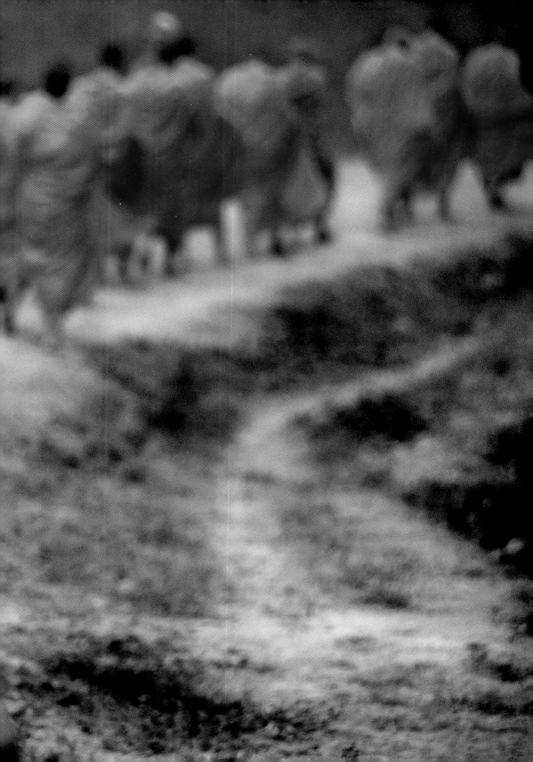

They had said goodnight lying next to one another, falling asleep under a light-blue mosquito net that in the day hung from the ceiling, rolled up like a snake on a branch, and as darkness fell descended light and transparent to the ground. Pan and Kum, husband and wife for sixty years, had decided to go to market the next day to buy a rope on which to hang the washing and nails to fix the piece of plastic in the bathroom window, which had broken in a gust of wind. But at dawn Kum was no longer there. She had gone, dying in her sleep. Pan had called her name softly, had caressed her face. Then he had shaken her and with difficulty had looked for a blanket to bring warmth back to her on that morning of spring reawakening, when the air catches fire at the rising of the sun. The old man had turned to face the wall and had closed his eyes, as if to give his wife time to recover from the torpor of the night, but in that brief darkness, in that heart-rending attempt to restart the regular heartbeat of the day, nothing had moved. Then Pan had telephoned his daughter: "come." That was all he had said. He had sat down in a corner, getting up only to dress himself in white as a mark of mourning.

Lem and other novices at Wat Xieng Thong were to take part in the funeral rite and later would put up Kum's grandsons in their cell. Monks for a night, it was their task to accompany their grandmother on her last journey, wishing her a happy rebirth. The following morning, after the *tak bat*, Phone, Sou and Jan, fifteen, seventeen and twenty years old, would go back to their normal life and only their shaved heads would be left to tell strangers that they had lost a loved one.

Lem had never seen a dead body. As a child he had gone with his father to offer their condolences to a neighbour who had unexpectedly lost her husband. But when father and son had presented themselves to the widow, the man's body had already been covered with all his clothes and looked like a gentle rise, like the foothills of a mountain chain. After they went home Lem's grandmother had described every phase of the ceremony to him, in the hope that the little boy would one day repeat each step with care, for her. First of all the corpse had to be washed twice, with hot and cold water, to remind the soul that it had now passed

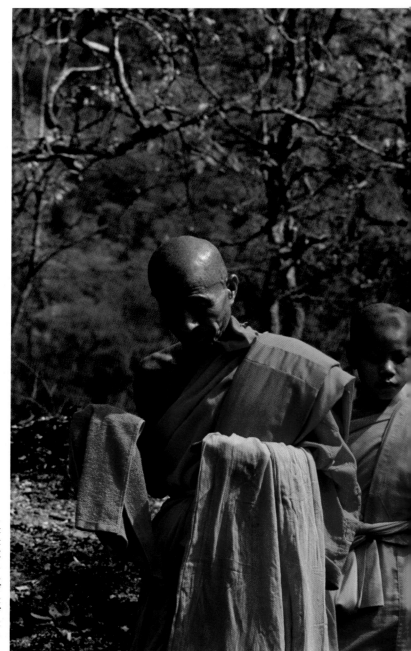

Concentration. In the nature that surrounds Wat Maiphao, during walking meditation, monks and novices learn to be aware of every movement. It is the beginning of a long inner quest that will lead them to mastery of the self.

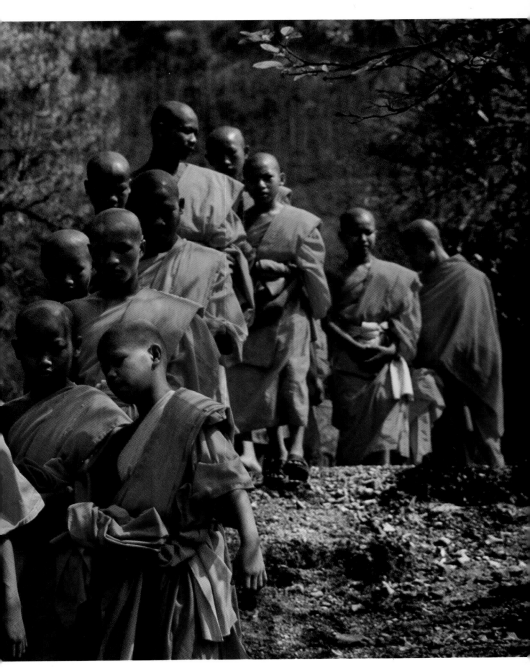

through the extremes of life. Then it was dressed, a first garment worn inside out and back to front, and on top of this the item of clothing of which the deceased was most fond, although with a button or a strip of fabric torn off. The link to life was severed and step by step the ritual reminded the dead that the time of departure was approaching. A few minutes more, time to tidy up the hair, throwing the comb away afterwards, and to seal the eyes and lips with a drop of honey, but not before placing a silver coin in the mouth. Then the body was put in the coffin. One last look and the lid was closed.

The lorry has arrived in front of the entrance of Wat Xieng Thong. Monks and novices take their place in the open back and at the last moment someone remembers that there may not be enough petrol. A dash, a jerry-can, a banana leaf rolled up by the driver and inserted in the tank, and the petrol is poured into the soft green of that strange funnel. Pan and Kum's house is twenty minutes' drive away. A throng of relatives, friends and the curious has gathered in the small garden in front of the entrance. No one is crying. The grandchildren are already wearing white robes.

Three monks, the oldest, sit next to the coffin on the satin cushions that Kum's daughter has prepared for them. Others ring the house with the blessed thread: no malign presence must come into this now sacred space. The men sit down in front of the monks and present the novices who will be entering the temple in a few hours. Everyone is hoping that the layabout and troublemaker Jan, known as the Playboy, will choose to take the vows forever. The prayers commence and Lem and his companions, who have remained in the garden up to now, help the three youths to put on the orange tunic. At the end of the prayers members of the family lift the coffin onto their shoulders, carrying it out feet first, so that Kum, like every dead person, will never be able to find the way back home nor be reunited with the living. Pan gets up and, keeping his eyes lowered, shuts the door.

On the flat area of the cremation ground stand three very tall funeral pyres built of concrete. The monks' lorry arrives several minutes before Kum, and Lem has time to explore the unfamiliar place, surrounded by a grey forest in which every tree compassionately cradles the ashes of the bodies among its branches. No bird seems to want to alight in their foliage, as if unwilling to offend the souls of those who have flown away.

In the pagoda in the middle, on the brick bier, is set a white sarcophagus, decorated with pieces of shiny paper. The family clusters around it. A man climbs the steps, approaches the coffin, uncovers it, and it is as if a breath of wind has sprung up. Those present take a step back and the first to go timidly to the coffin are two novices, who gaze in silence at the face of their mother, killed in a road accident. The body is wrapped in a white cloth, covered with incense. Someone cuts open a coconut with a machete and offers it to the boys, and that sharp sound of parting echoes from the blackened vault of the crematorium and falls back to the ground, carrying with it the grief of endless bereavements. The elder son plucks up his courage and gently, without shedding a tear as is required by Buddhist decorum, pours the coconut milk onto his mother's face. Then it is his brother's turn. May that fragrant liquid be the nourishment of a new life. But before closing the coffin love begs for another moment of light, so that the sons can stay close to their mother and go back with her in time, now that there is no longer a future, now that death has swapped their roles and it is the children who give milk to the woman who gave birth to them and nursed them.

Kum's procession has arrived. Lem moves closer, following every phase, and now he too sees that face, those closed eyes, two pits that the coconut milk has filled like a lake. A line forms and one by one, first the eldest son, then the daughter, relatives and friends light the pyre with a brand. Each tongue of flame is a farewell. The *khouan*, eternal spirits of life, have left the body. Fire engulfs the coffin, conquers, concludes. The pyre will burn all night, until it is reduced to a few glowing embers. But while the flames are still high, Kum's family takes shelter in the shade of a canopy, under which dozens of monks and novices have found refuge. The largest group has attended the funeral of an army officer. Isolated, looking like an improbable expanse of perpetual snow, a group of nuns cloaked in their immaculate robes watches the ceremony and prays for the deceased. Their convent is next to the crematorium. Lem observes them and notices among those elderly women a girl, she too with her head shaved, but very beautiful in the lines of her neck and arms that can be glimpsed through the shawl. If he could have asked her to tell him her story, Lem would have discovered that the thirteen-year-old novice is called Kew, "precious" in the Lao language, and that it had been her father who had cut off her hair and shut her up in a convent, accusing her of thinking too much about boys.

207

Her mother comes every evening to see her and prepare a glass of milk for her. They weep together.

Not far from Kew's temple, at the foot of a tree on the edge of the wood, an old monk sits in meditation. Only now does Lem realize that the isolated figure had been there before the funeral began. He seemed to blend into his surroundings, offering his own silence to the silence of death and embracing in the peace of his thoughts the inevitable shabbiness of the place, with its stacks of firewood and bunches of faded flowers dumped on the ground. Lem would have liked to approach him, attracted by that radiant stillness. Without making a sound, he would have sat down next to him and, trying to bring his own breathing into step with that of the Venerable monk, attempted the simplest exercise of meditation, control of the vital breath: the air enters through the nose, dilates the nostrils, continues on its way to the lungs, lifting the belly, and then rises again to the lips and returns to the world. And to help the mind to concentrate, the novice would have accompanied each step with a movement of the hand, from the chest to the mouth, stretching out the arm until it descended again and joined the other hand resting on the robe. Eventually the master would have explained to his young pupil that by meditating one looked at things deeply and discovered the true nature of the mind, cleansing it of every doubt and false idea. "Meditating, Lem", that wise man would have said, "you will find that everything is mutable and nothing belongs to you, not your body, not even your intelligence. Everything is illusion, everything inevitably comes to an end. I was late in understanding it."

The monk, who is now getting to his feet, massaging his aching back and knees, is named Peuy. An old tortoise, he calls himself. As a young man he had fought in the king's army and in 1975 had been captured by the Pathet Lao and sentenced to four years in a re-education camp in the mountains. On his return to Luang Prabang, his health ruined, he had found a job with the river traffic authority. Then with the arrival of foreigners he had opened a small hotel, "and I thought of nothing but money, making money." But one day Peuy had discovered that the most important account, the one with his future life, had remained outstanding. To resolve his doubts he had asked for help from no one except the Dhamma, "for Buddhism teaches you to think for yourself and to find the right way on your own." One evening, at supper, he had announced

210

to his now grown-up children his decision to take vows and enter a monastery. Like Satu Sai, Peuy had founded his own community: just two twelve-year-old novices in a small village across the Mekong. But every so often the old monk came back to the city for a medical examination and that day had chosen the cremation ground as a place for meditation. Kum's family begins to make its way home. Pan's son helps him to climb up next to the driver, on the lorry that transported the coffin. It is followed by a line of vehicles. No one turns round to look at the coffin that is still burning. Tomorrow they'll all come back to collect the ashes and the children will look in them for the silver coin that their grandmother has kept in her body for them. Then her remains will be scattered in the river, as Kum had requested years ago. Stupas, she said, are not for men and women, but for the Buddha alone.

On the pickup that is going back Wat Xieng Thong, the monks make room for the three young men who will be sharing their destiny for a day. Lem looks at them, smiling at the unease that is betrayed by their gestures, at their haste to get back to their usual activities, but for the first time the little novice feels no envy. Conjuring up his memory of Peuy, of his composed and reassuring figure, Lem tries to retrace the course of his thoughts. Perhaps, hidden behind the shadow of resignation, he has glimpsed a different light, and through that chink he imagines himself older, seated under the Bodhi tree, the tree of the Buddha's enlightenment. And while the lorry rushes along and the wind sweeps away the smell of the fire and the burning body, Lem lets his imagination wander farther: it is night, his breathing is calm, his eyes turn inwards and explore a hitherto unknown continent. In the silence of the forest his mind observes every emotion, analyses it, dismisses it and without regret senses that desire is the origin of all suffering.

The little novice does not know yet if he will arrive at this goal, for he still desires so much from life, but he knows that he wants to try, perhaps in a few months during the long retreat in the mountains on which Satu One Keo, prior of Wat Pak Khane and Wat Xieng Thong, wants to take them. Lem thinks about his own village in the mountains and recalls when the old people used to tell stories of the monks, isolated in the depths of the jungle to contemplate the mysteries of existence: "and if by chance they dropped a handful of rice while eating their modest meal they had to bury it at once, otherwise the tigers would have caught

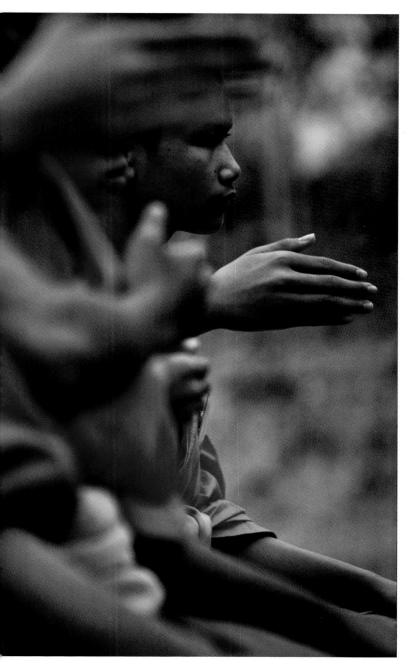

pp. 208-209:
Nothing is forever.
Fire has destroyed
part of the forest
around Wat Khok
Pap. Amongst the
ashes a novice medi-
tates on the imper-
manence of things.
Reality is illusion, at-
tachment is suffering,
the cycle of rebirths
is an affliction.

Awareness.
In the park of
Wat Maiphao, a
temple-school a few
kilometres from
Luang Prabang, the
novices embark on
their first exercises
of Vipassana medi-
tation. Controlling
the movement of his
breath, Lem too sets
out along the difficult
path of awareness.

the smell of food, of human food, and would have hunted them down and devoured them." Lem shivers and wraps his robe around him. He notices that the hem is stained with ash and as he tries to clean the cloth he seems to hear the voice of the monk Boun, his first teacher. "Novice, let the dust of our body, what we will become one day, stay close to you at least for today, and remember that the Buddha wanted our habit to be made from the rags abandoned in cemeteries as a mark of humility." But at the thought of death, imagining the flames playing over Kum's face, now unrecognizable, Lem feels all his childhood re-emerge, and it is as if that brief past that belongs to him and that nourishes him filled every fibre of his body, every muscle, every drop of blood. And then closing his eyes, feeling the warmth of the sun on his face, the little novice thinks of when his grandmother, who was sewing tunics for the monks, recounted to him one of the many episodes of the Buddha's life. "One day, walking in the Indian countryside, the Enlightened One explained to Ananda that the robe of the new order should resemble the pattern of a rice paddy: a long strip of fabric divided into many squares. Each seam was a path, each action worthy of merit, each act of charity was a rice seedling that would bear its fruits." The robe that Lem had put on a week earlier, in the presence of his family and the monks of the temple of Wat Nam Nga, was nothing but earth and water, and without knowing it the little novice was wearing the rice fields cultivated by his father and the water that his mother went to fetch from the river. That robe would grow with him, would sprout on his skin, would offer, year after year, its harvest. Lem is at home.

Actions never vanish,
not even in hundreds of cosmic eras;
when they attain the right conditions
and the moment is propitious,
they certainly bear fruit for he who has generated them.
(Adhikaraṇavastu)

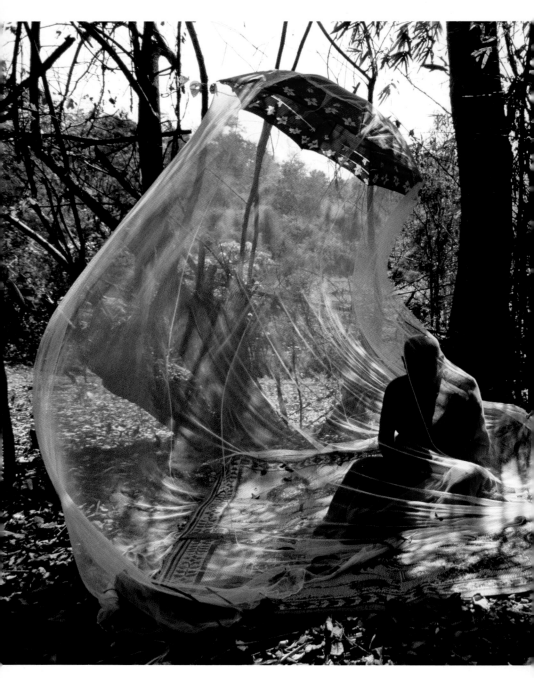

Nirvana.
In silence Satu Peuy recalls the teachings of the Buddha. Meditating in the Deer Park, the Master understood the truth of suffering and the way to overcome it: only by divesting themselves of all things can human beings free themselves from desire and find peace.

217

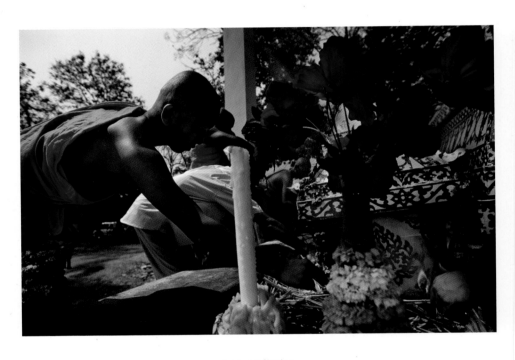

Intermediaries.
In Theravada Buddhism only monks can reach Nirvana.
But the entry of children and grandchildren into the monastery, even for just a few days,
helps the soul of the deceased to be reborn to a better life.

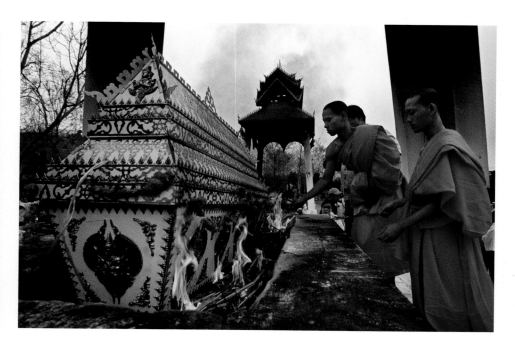

Passages.
In Laotian Animism death is seen as a liberation and the start of a happier existence.
The eternal spirits, the khuan, have now flown away and the body of an old woman is entrusted to the flames, lit by her grandsons.